THE BOOK OF

KELLS

ART · ORIGINS · HISTORY

THE BOOK OF
KELLS
ART · ORIGINS · HISTORY

IAIN ZACZEK

PB
PARKGATE
BOOKS

Acknowledgments

While writing this book, I have been lucky enough to receive advice and encouragement from a number of friends and colleagues. Special thanks are due to Ian Chilvers, for the use of the Jesmond Research Centre, and to Maura Thunder, for her patience and support. I am also grateful to Petrina Beaufoy Helm, Peter Herzog, Michael Jacobs, Caroline Juler, Françoise Sciré, Michael and Marianne Sherbourne, John Vernon, Hat Visick and Wanda Zaczek. Finally, I would like to dedicate the book to Mike Draper, in memory of our Irish trip.

All illustrations come from The Book of Kells unless otherwise specified.

First Published in Great Britain in 1997
by Parkgate Books Ltd, London House,
Great Eastern Wharf, Parkgate Road,
London SW11 4NQ

Text copyright © Parkgate Books Ltd

British Library Cataloguing in Publication Data:
A CIP catalogue record for this book is available from the British Library.
ISBN 1–85585–312–4

1 3 5 7 9 8 6 4 2

Edited, designed and typeset by
Book Creation Services Ltd, London

Printed and bound in Hong Kong by Dah Hua

CONTENTS

factus est tues filius meus dilectus inte·

bene conplacuit mihi ⸙

Ipse ihs erat incipiens quasi an

norum triginta utputabatur filius

ioseph

vi fuit heli

vi fuit mathat

vi fuit leui

vi fuit melchi

vi fuit iannne

vi fuit ioseph

vi fuit mathat hie

vi fuit amos

vi fuit nauum

vi fuit esli

vi fuit nagge

vi fuit maath

CHAPTER 1

BACKGROUND

 The Book of Kells is the crowning achievement of Celtic art. It is also one of the finest illuminated manuscripts ever produced, combining intricate calligraphy with ornamental designs of exquisite beauty. Alongside, there are the imposing figures of angels and saints, the harbingers of the Christian faith, who stare out at us with a solemn majesty. Together, they convey both the missionary zeal of the artists who fashioned the book and the sense of awe that it must have inspired in new converts.

The decorative qualities of the Kells

Opposite: The Genealogy of Christ, fol. 200r.

manuscript are unparalleled, but its style and content are far from unique. It is just one of a series of richly ornamented, evangelical works that were produced in Britain and Ireland during the early Christian period. As such, the Book of Kells may be said to mark the dawn of a new era. In artistic terms, however, it comes at the end of a very long tradition, one that stretches far back into the mists of the prehistoric world.

No-one can be absolutely precise about the origins of the Celts, but it is generally accepted that they were a loosely knit group of peoples, sharing certain elements of a common language and a common culture.

It appears that they flourished initially in Central Europe, particularly in the area around Upper Austria and Bavaria, and their roots can be traced back to the later stages of the Hallstatt era (c.600 BC–c.450 BC). In the age which followed this, the La Tène era (c.450 BC–c.50 BC), the power and influence of the Celts increased enormously. For a time, they held sway over much of Europe, from the shores of Ireland to the foothills of the Balkans.

During the period of their ascendancy, Celtic craftsmen developed a very distinctive type of decoration. Using a varied repertoire of semi-abstract forms – spirals, knots, snake-like interlacing, and stylized human and animal shapes – they created the hypnotic, maze-like patterns that we have come to know as the Celtic style. The ancient Celts applied these designs to a wide selection of artefacts, ranging from weapons and armour to household goods and jewellery, but the style itself remained popular long after the close of the La Tène era. Christian artists adapted the swirling, spiral forms for their own use and these mesmerising patterns lie at the heart of the decoration in the Book of Kells.

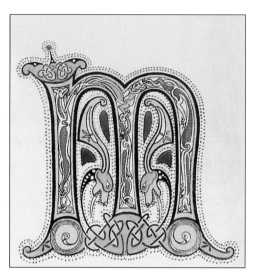

Initial Letter, Lindisfarne Gospels.

There are good reasons why the Celtic style became so firmly associated with the western fringes of Europe. In the main, they relate to the historical fate of the Celts. As the armies of Rome surged across Europe, they pushed the Celtic tribesmen out of their ancient territories or else absorbed them into the Empire. Ireland and the outer limits of the British mainland never came under direct Roman rule, however, and it was here that Celtic artistic traditions survived in their purest form.

In due course, the patterns that had featured so prominently on La Tène metalwork and jewellery were reproduced on Christian artworks in Britain and Ireland. They were not limited to manuscripts, but also appeared on items such as croziers, chalices and reliquaries. The strength of native traditions in this field can be explained by the independent character of the Celtic Church. The conversion of Britain and Ireland had taken place on two distinct fronts. In part, it was achieved by official delegations from Rome, most notably that of St Augustine (596–7), and in part by the missionary endeavours of figures like St Columba, St Patrick and St Aidan. The monastic communities that were founded by these pioneers enjoyed an unusual degree of autonomy from Rome. There was no major disagreement over matters of doctrine, but considerable divergence on questions of organisation and liturgical practice. The fiercest debates surrounded the dating of Easter, which both parties calculated in a different manner, and there were further arguments about the wearing of the tonsure and the merits of the diocesan system.

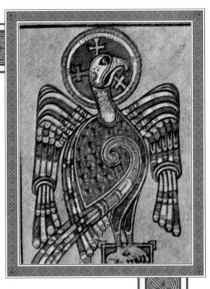

From an artistic point of view, the comparative isolation of the Celtic Church had beneficial side-effects. Manuscripts and church plate were not imported directly from the Continent or slavishly copied from Roman models, but were made locally in native styles. All the great monastic centres – places such as Iona, Lindisfarne, Durrow and Kells – set up special workshops where monks laboured over the production of manuscripts. These workshops were known as scriptoria. There appears to have been considerable interchange between the various monasteries, and it is often hard to gauge where specific manuscripts were made. Stylistically, there is little to distinguish an Irish example from one produced in Iona or Northumbria. Accordingly, these manuscripts are commonly described as 'Insular'. This is partially to differentiate them from Continental texts and, perhaps more importantly, to avoid any prickly nationalistic issues.

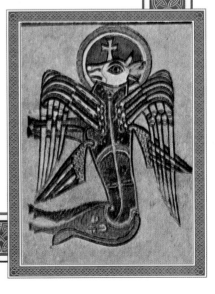

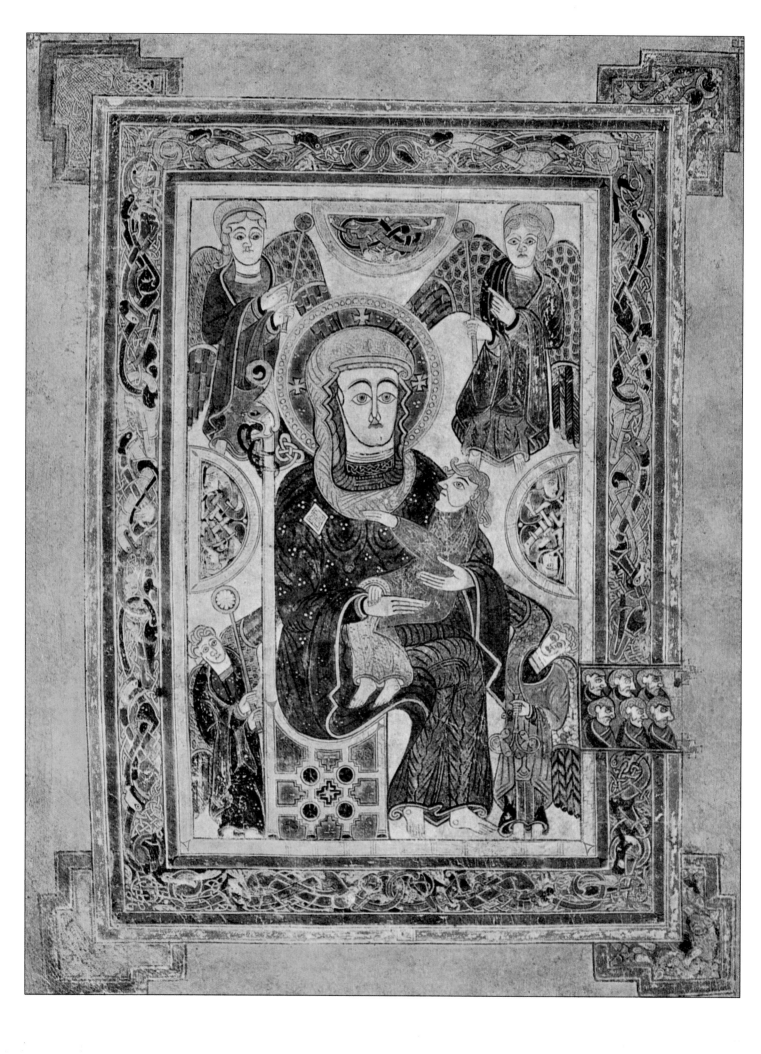

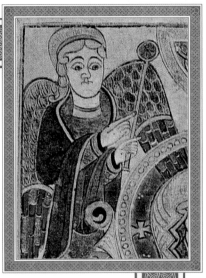

The dispute with the Papacy was eventually resolved at the Synod of Whitby in 664. There, officials in the Celtic Church finally agreed to accept Roman liturgical practices. Even so, this did not bring the Celtic influence to an end. For, by this stage, the quality of the manuscripts that were being created in British and Irish scriptoria had reached a very high standard. Acknowledging this, the authorities in Rome sent across books and manuscripts to be copied. At the time, there was a pressing need for substantial quantities of new biblical texts, as the Church was arranging missionary expeditions into the heathen areas of northern Europe. British monasteries co-operated fully in these ventures.

In some cases, this resulted in the direct export of Celtic styles to the Continent. Two of the leading missionary figures were St Columbanus, an abbot from Leinster, and St Willibrord, from Northumbria. The former established important monastic centres at Luxeuil and Bobbio, while Willibrord was responsible for the great monastery at Echternach. Each

Opposite: The Virgin and Child, fol. 7v.

of these had their own scriptorium, producing manuscripts in the traditional Celtic manner.

The decisions taken at Whitby had far-reaching implications for the development of manuscript illumination. The importation of books from the libraries of Rome exposed monastic artists to a wide variety of new influences. The consequences of this can be seen most clearly in the treatment of figures, which had always played a comparatively minor role in Celtic art. In the Book of Kells, for example, it is clear that the picture of the Virgin and Child was based on some foreign source. There are no obvious antecedents for it in British or Irish art, although there are close affinities with Byzantine images.

Eastern influences of this kind might easily have been channelled through Rome, for, during the period in question, the Byzantine Empire was in the grip of iconoclastic fervour. Images of Christ were deemed sacrilegious, tantamount to idolatry, and a succession of emperors tried to suppress them. Known as the

'Iconoclast Controversy', this problem divided opinion in the East from the early 8th century until 843, when the Empress Theodora repealed many of the more punitive measures. In the intervening years, Byzantine artists flooded to the West in search of work. Many of them settled in Rome, encouraged no doubt by the cosmopolitan nature of the Papacy at this time. John VI, John VII and Zacharias were all of Greek extraction, while Sisinnius, Constantine and Gregory III were Syrians.

The transmission of manuscripts from Rome to Britain is fairly well documented, but the creators of the Book of Kells probably also had access to artworks from other parts of Christian world. In particular, commentators have often noted its affinities with Coptic and Syriac manuscripts. The former seem to have provided the inspiration for many interlace designs, as well as the general layout of Carpet Pages (see page 62),

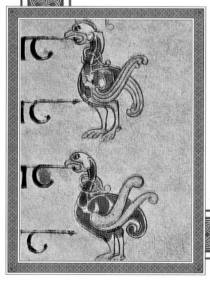

while Syriac illuminators pioneered the use of narrative illustration in their biblical texts.

The precise nature of these cultural contacts is hard to determine. Archaeologists have found some evidence of trading links between the British and Irish Celts and the Christian communities of the Near East. Identical fragments of pottery, dating from the 5th and 6th centuries and stamped with the image of the Cross, have been found in both Celtic and Coptic monasteries. These fragments were probably from jars containing oil used in the liturgy.

Small religious artefacts may also have been carried to Britain and Ireland by independent travellers. A few tantalising accounts confirm that some intrepid Christians did manage to travel beyond the confines of Europe. It is known, for example, that a monk named Cassian journeyed from southern Gaul to visit Coptic centres in Egypt. Similarly, a Frankish bishop called Arculf made a lengthy expedition to the Near East in 679–82, visiting sites that were mentioned in the New Testament. On his return, he was blown off course to Iona,

Opposite: The Geneaology of Christ, fol. 201r.

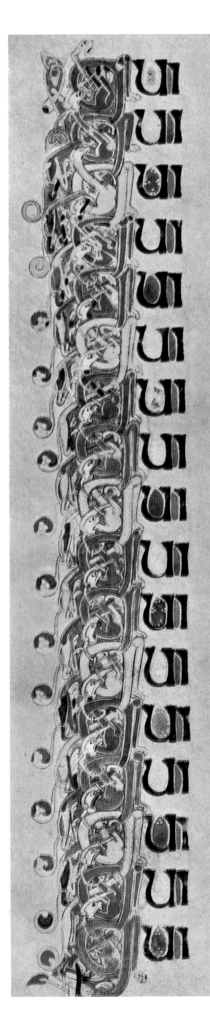

fuit	zorim
fuit	mathat
fuit	leui
fuit	semeon
fuit	iuda
fuit	ioseph
fuit	iona
fuit	eliacim
fuit	melcha
fuit	menna
fuit	mathathia
fuit	nathan
fuit	dauid
fuit	iesse
fuit	obed
fuit	boos
fuit	salmon

where he related his experiences to Adomnan, the future biographer of St Columba. Adomnan proceeded to set these down in a book, De Locis Sanctis (The Holy Places, 683–6). It is tempting to wonder if the bishop might have parted with some memento from his travels – a portable Gospel Book, perhaps, or a small painting – out of gratitude to his unexpected host. Images such as these could then have served as models for the artists working on the Book of Kells a century or so later.

Historians have often speculated with theories such as these. They are feasible, but ultimately unprovable. The only certainty is that the stylistic features in the Book of Kells were drawn from a wide variety of sources and were honed to perfection over a considerable period of time.

Opposite: The Opening Words of St Mark's Gospel, fol. 130r.

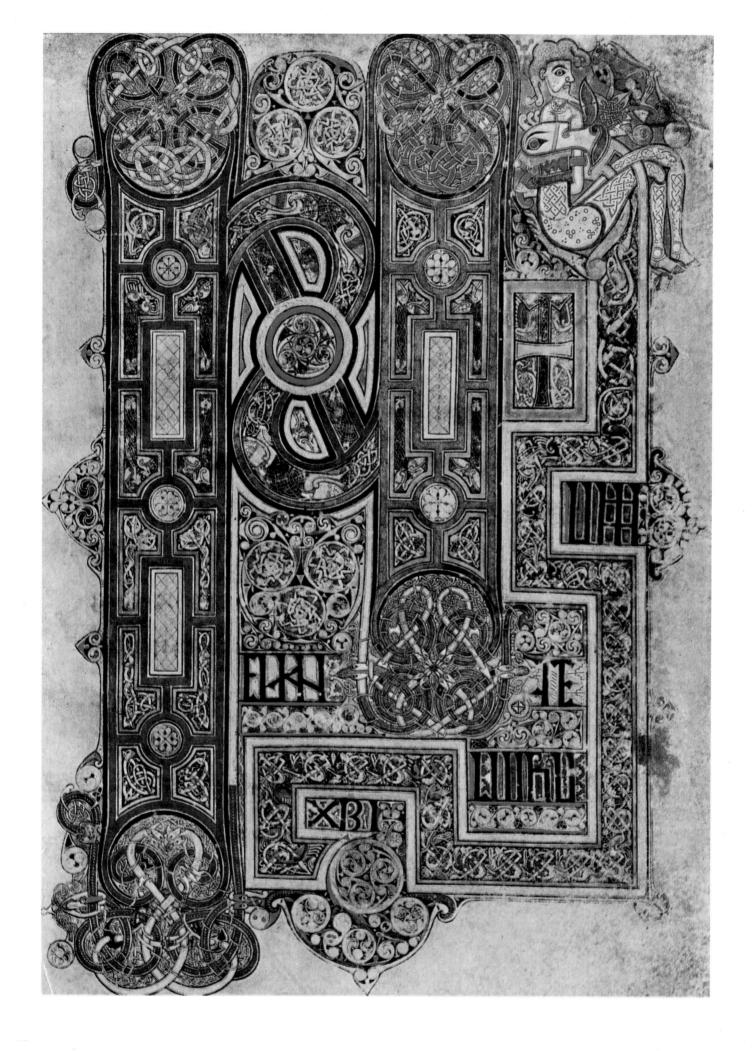

Ae autem praegnantibus et

nutrientibus inillis diebus

Rate autem utnonfiat fuga

uestra hieme · uel sabbato

Rit enim tunc tribulatio magna

qualis nonfuit abinitio mun

di usque modo neque fiet

Et nisi breuiata fuissent dies

illi nonfiere · salua om

nis caro sed propter electos bre

uiabuntur dies illi

Tunc siquis uobis dixerit · ecce

hicxps autillic nolite credere

Rient · enim pseudoxpi et

pseudo profetae et dabunt

signa magna et prodigia ita inerro

rem inducantur si fieri potest etiam

GOSPEL BOOKS

 Because of its fame, there has always been a temptation to view the Book of Kells in isolation. It sometimes seems as if the manuscript appeared out of vacuum, a solitary jewel saved from the wreckage of the Dark Ages. In reality, it formed part of a tradition that had been developing steadily in the British Isles, since the arrival of the first Christian missionaries. Indeed, the written word was to prove one of the most vital tools in the entire conversion process.

Despite this, the real impact of the early Gospel Books depended on something more than the bare bones

Opposite: Page from St. Mark's Gospel, fol. 104r.

of the text. The physical appearance of this type of book was equally important. It was designed to create a sense of wonder in all who witnessed it, as a famous passage by Giraldus Cambrensis confirms. Writing in his Topographia Hiberniae, this 12th-century chronicler gave a stirring account of a Gospel Book that he came across on his travels:

This tome contains the concordance of the four Gospels according to St Jerome, with different designs on almost every page, all of them in a marvellous variety of colours. Here, you can gaze upon the face of divine majesty, drawn with infinite grace. Here, too, are the mystical emblems of the

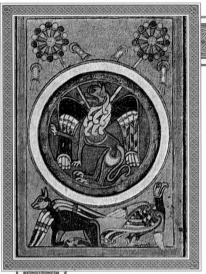

Evangelists, now with six wings, now with four, and now two. Here, you can find the Eagle, the Calf, the Man, and the Lion, along with a host of other wonders. Look at them casually, with just a superficial eye, and you may think them rapid sketches, rather than the fruits of genuine labour. You may think them shallow, where all is subtlety. But, if you take the time to examine more closely, you may penetrate to the very shrine of art. You will see intricacies, so fine and subtle, so exact and yet so rich in detail, so full of knots and coils, with colours so bright and fresh, that you will not hesitate to declare that you have gazed upon the work, not of men but of angels.

This is the description of a book that Giraldus saw in Kildare, when he passed through the area in 1185. If it were not for the hyperbole, there would be no reason to suppose that he was referring to the Book of Kells. Nonetheless, a comparison is often drawn between the two, simply because Giraldus's comments conjure up so vividly the sense of wonder that the early Gospel Books must have inspired.

For contemporaries, there was indeed something almost angelic about these sacred texts. When associated with a saint, they were revered as holy relics. On some occasions, they were even buried with the man. This happened in the case of St Cuthbert. A Gospel Book was interred with his body, when he died in 687, and was only removed when his bones were exhumed in 1104.

In other contexts, both spiritual and secular, early Christian texts were often believed to possess near-magical

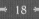

Evangelist Symbols, fol. 129v.

Opposite: Compound letters PRopter and EXsurgent.

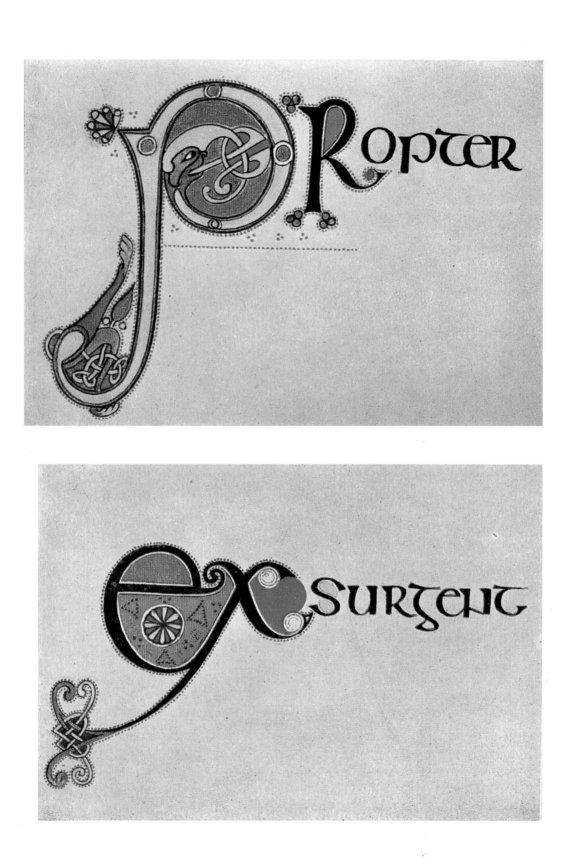

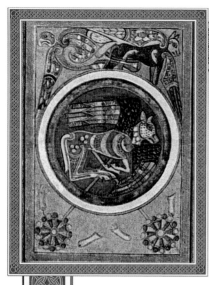

properties. A typical example concerns the Cathach, the fragment of a 6th-century psalter which is thought to be the oldest surviving Irish manuscript. The literal meaning of the word is 'Battler', a name that was acquired because the owners of the book used it as a talisman in times of warfare. Before entering the fray, they would circle round the army three times, carrying the book in procession, in the hope that it would bring them victory.

The Church did nothing to discourage this type of reverence. In his Life of Columba, Adomnan described a number of miracles relating to books. One of these concerned a satchel of books that was dropped by accident into the River Boyne. When the satchel was recovered three weeks later, all the books had rotted, save for a single page that had been written out by St Columba himself. This remained dry and unblemished, as if it had never been in the water. During Adomnan's own lifetime (c.628–704), Columba's books were placed on the altar at Iona before any sea voyage was undertaken, in the hope that this would procure favourable winds for the journey.

Echoes of these beliefs persisted for many centuries. One of the most bizarre examples concerns the Book of Durrow, which fell into private hands after the dissolution of the monasteries. So strong was the aura of mysticism which still clung to the book, that its new owners used it to effect a cure in their sick cattle. The precious volume was solemnly dipped in water and the ailing beasts were then persuaded to drink from the same source.

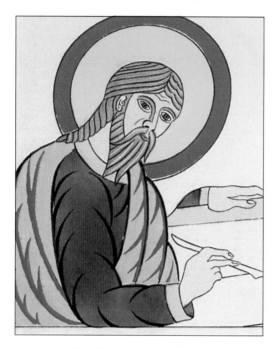

St Matthew, Anglo-Saxon Gospels

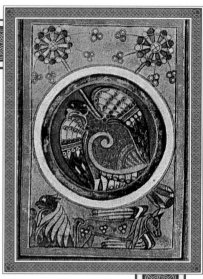

Initially, however, the main purpose of the Gospel Books was to oil the wheels of conversion. Missionaries carried the texts with them on their travels, using them to preach to potential converts. Gospel Books were preferred to complete Bibles for a number of reasons. Firstly, the work of conversion was centred on the details of Christ's life. On a practical level, the smaller volumes were easier to transport and, most important of all, quicker to produce. In general, there was less emphasis on decoration in these portable items and they were written in minuscule script. Several of these so-called 'Pocket Gospels' have survived, the most notable examples being the Book of Armagh, the Book of Dimma, and the Mulling Gospels.

As Christianity took root and monastic centres were established, manuscripts were required to fulfil a

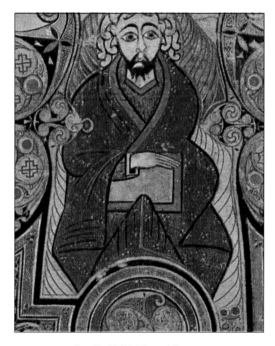

Detail of Initial Page, fol. 292r.

variety of different functions. Detailed and accurate texts were needed for use within the monastery, to help train new monks. Similarly, manuscripts of a more striking nature were required for liturgical purposes. These would be used in special ceremonies and processions, or else just displayed on the altar.

The Book of Kells fell into this final category. This can be deduced both from the extraordinary beauty of the illuminations and, conversely, from its inadequacies as a text for serious study. For all its visual splendour, the Kells manuscript has some major flaws. The text itself contains considerably more errors in transcription than most Insular books of its kind. Indeed, one entire page was written out twice, by mistake. This

cannot have been caused by a desire for haste or for reasons of economy, given the time and attention that was lavished on other sections of the book. It can only have occurred because the scribes were well aware that their text was never going to be read. Further confirmation of this can be found in an early historical reference to the manuscript. When the Book of Kells was stolen in 1006–7 (see page 28), the annalist noted that it was taken from the sacristy, not the library.

In spite of its varying functions, the format of the Gospel Book was established at a fairly early stage and remained remarkably consistent. Features such as the Evangelist portraits, the enlargement of certain initials, and the Canon Tables were all borrowed from Late Antique manuscripts and were rapidly assimilated into Insular traditions. The earliest surviving example is the Cathach, which dates back to the late 6th century. Other landmarks include the Book of Durrow (late 7th century), the Lindisfarne Gospels (c.698), the Durham Gospels and the Lichfield Gospels (both early 8th century), the St Gall Gospels and the MacRegol Gospels (late 8th century), and the Book of Armagh (807–9). The Book of Kells is thought to date from the end of this sequence.

The text used in most of the Gospel Books was drawn from St Jerome's Latin translation of the Bible, which is better known as the 'Vulgate'. This was commissioned by Pope Damasus in the late 4th century, when it became apparent that the existing versions – the so-called 'Old Latin' texts – were no longer adequate. In the case of the Book of Kells, the text was composed of a slightly archaic mixture of the Old Latin and Vulgate versions.

In addition, most Insular manuscripts contained a selection of prefatory matter, such as Canon Tables, Breves causae, and Argumenta. These sections were principally designed to help the monks find their way around the text. It should be remembered that, at this stage, the verse and chapter divisions of the Bible had not yet been devised. The enlarged initials and the illustrations

Opposite: Canon Table, fol. 5r.

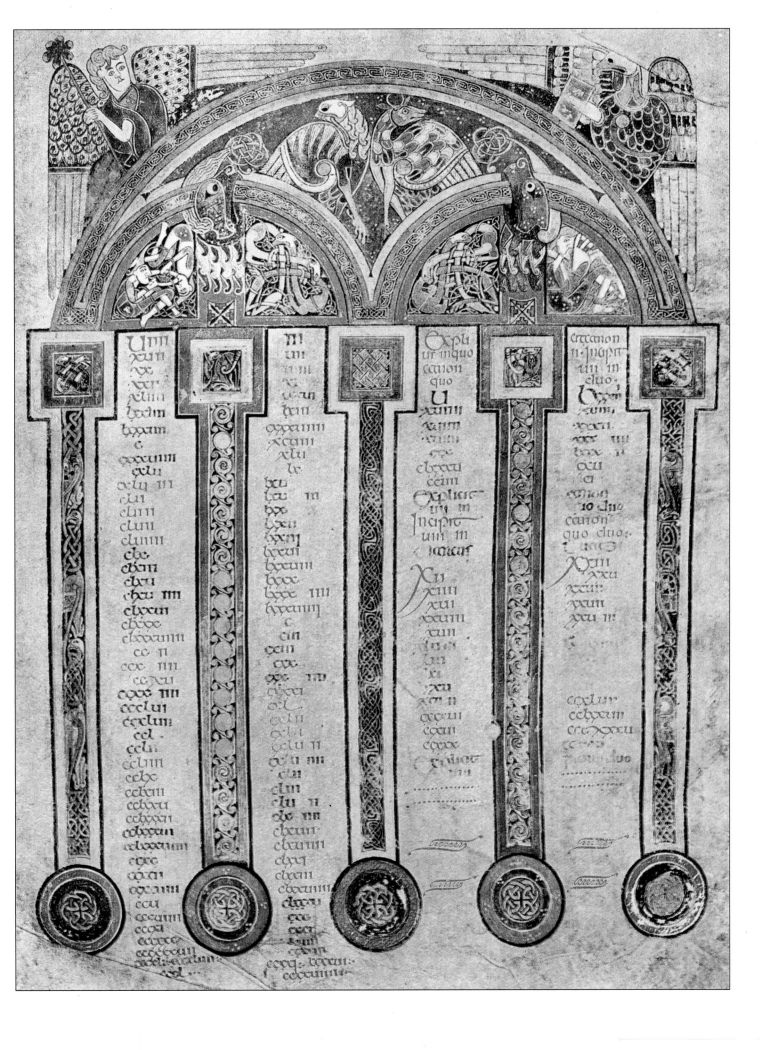

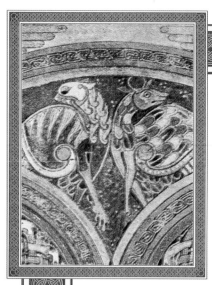

could assist the reader in finding some of the most important passages – indeed, this was the original function of much of the decoration – but it still left him with some uncomfortably dense blocks of text.

It was precisely for this reason that the Canon Tables were invented. The system was devised in 320 by Eusebius, the Bishop of Caesarea and the tables are sometimes also known as the 'Eusebian Canons'. In these, individual sections of the Gospels were numbered and listed in four columns, one for each of the Evangelists. The theory was that, by cross-referring from one column to the next, it would be easier to find any given passage in the text. In the case of the Book of Kells, however, the

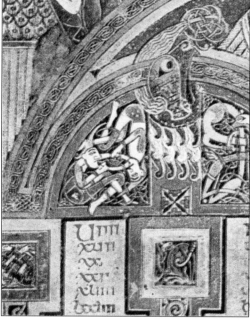

Detail of Canon Table, fol. 5r.

numbering of the different sections was never entered in the text so that, for all practical purposes, the tables were useless. Once again, this underlines the fact that the Kells manuscript was never intended to be used as a tool for learning or research.

Instead, the Canon Tables provided the illuminator with an admirable opportunity to show off his skills. The lists are framed in a series of Classical arcadings, which are clearly derived from Late Antique models. In adapting them, the artist has flattened out the architectural forms and filled them with a fine array of ornamental motifs. Perhaps the finest of the series is the example on fol. 5r. This is dominated by the symbols of the Evangelists (for further details of these, see chapter 4), which preside over their respective columns. Thus, reading from left to right, we can see the winged man, the lion, the calf, and the eagle. These are

not straightforward depictions, however, for the eagle sports a human hand, while both the lion and the calf are combined with the rear end of a peacock. The remainder of the decoration is typical of the Celtic La Tène style. The fierce, biting heads are reminiscent of belt buckles or the clasps on items of jewellery. Similarly, the other figures in the tympanum – the disconsolate contortionist, the beard-tuggers, the snake-like creatures – all have their echoes in Celtic stonework and metalwork.

The Breves causae and the Argumenta both provided supplementary information for the reader. The former were brief summaries of the Gospels, while the latter contained a variety of anecdotal details about the individual Evangelists. As with the Canon Tables, the reference numbers in the Breves causae are

Detail of the Breves causae, fol. 19v.

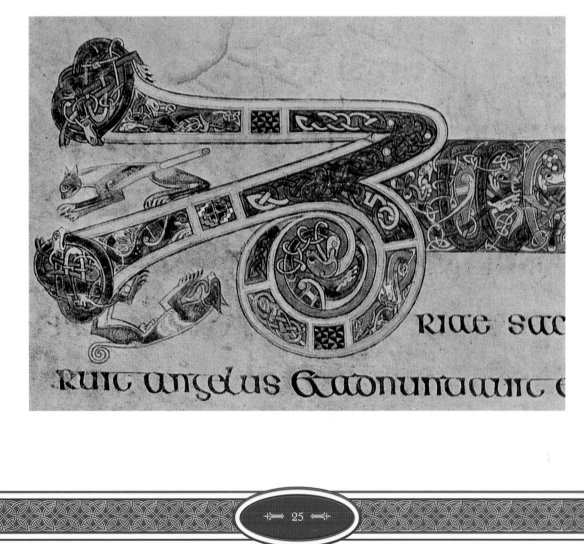

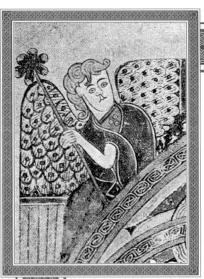

As with the Canon Tables, the reference numbers in the Breves causae are missing although, in this instance, there is a sound reason for the omission. The summaries in the Book of Kells relate to the Old Latin text, while the Gospels themselves are mainly taken from the Vulgate. One further peculiarity is the order of the Breves causae and the Argumenta. In most cases, these were divided up and placed before the relevant Gospels. In the Kells manuscript, the sequence is much more complicated, a characteristic which is shared by the Book of Durrow. This, combined with other textual similarities, has led some authorities to suggest that both books were taken from a common source or,

alternatively, that the scribes working on the Kells manuscript actually had access to the Book of Durrow itself.

Whatever the failings of these prefatory sections, they did nothing to dampen the enthusiasm of the Kells artist. Both the Breves causae and the Argumenta contain some splendid examples of Celtic calligraphy. The highlight of these is probably to be found on fol. 19v, where the opening word, Zachariae, is enlivened by some highly imaginative zoomorphic features. Much attention has also been focused on the strange, cat-like creature that is prowling near the centre of the 'Z', waiting to pounce on a smaller animal trapped inside the letter. The curious articulation of the creature's hip joint has strong affinities with the beasts that are found on Pictish stone-carvings. This has fuelled the theories of

THE MANUSCRIPT

 The greatest mystery surrounding the Book of Kells is its origin. The complexity and extravagance of the decorated sections confirm that it is one of the later Celtic manuscripts, and most authorities agree that it must date from around 800. In part, this can be deduced from the sophistication of certain key pages in the document. The flamboyance of the decoration on the Monogram Page, for example, was not the brainchild of a single illuminator. Individual motifs and flourishes had been evolving gradually for more than a century, in other versions of the manuscript. In addition, there are specific stylistic features that link Kells with other Gospel Books of the period. In particular, historians have noted the similarity between the 'tubular' appearance of its drapery and that of the clothing featured in the Book of Armagh. This is useful, as the latter can be securely dated to 807–9.

The ambitious scope of the book also suggests that it may have been designed for some special purpose or to mark some significant event, although there is no documentary

Portrait of St John, fol. 291v.

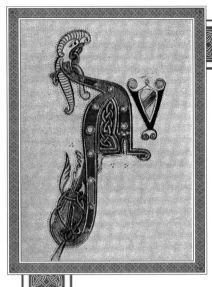

evidence to support this. Even so, it is clear that the manuscript was held in high esteem from an early stage. A tradition soon arose that St Columba himself had copied out the text and, as a result, the manuscript was treated with the same reverence as a holy relic. Since Columba died in 597, this association cannot be historically accurate, but it is hardly surprising that stories of this kind should have been woven around such a fabulous object.

The splendour of the manuscript did not always attract the right sort of attention. The very first mention of the Book of Kells was almost its epitaph. In an entry under the year 1006–7, the chronicler of the Annals of Ulster described how the manuscript was nearly lost to posterity:

The great Gospel of Columkille [St Columba], the chief relic of the western world, was wickedly stolen during the night from the western sacristy of the great stone church of Cennanus [Kells] on account of its wrought shrine. That Gospel was found after twenty nights and two months with its gold stolen from it, buried in the ground.

The 'shrine' in question would have been the cover or box, in which the book was stored. These were often adorned with precious metals and jewels, and it was clearly this, rather than the manuscript itself, which tempted the thief. The rough treatment which the book received at this time severely hampered later attempts at identification. For, by hastily ripping off its covering, the felon destroyed any inscription or dedication that the manuscript might have contained.

Nevertheless, the long association with St Columba must make Iona the likeliest source for the book. The saint founded a monastery on this tiny Scottish island in c. 563 and remained there as abbot. For the rest of his life he was, as his biographer put it, an 'island soldier', spreading the word of God in the surrounding region. Following his death in 597, Columba was buried at Iona and a series of miracles were rapidly attributed to him. His grave was marked by a simple slab, said to be the stone pillow that he had used during his lifetime, and his former belongings were soon revered as holy relics. At some stage, the Book of Kells appears to have been added to this collection.

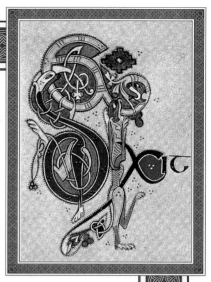

The importance of Iona continued to grow over the course of the next two centuries. It became the head of a confederation of other monastic foundations, all of which followed the spirit of the saint's teachings. This influence extended to Ireland and to parts of northern England and Pictland. In view of this, there can be no doubt that the community at Iona would have had both the wealth and the manpower to produce manuscripts of outstanding quality.

The fortunes of Iona began to change, however, at around the time when the Book of Kells was produced. The island's exposed position made it an easy prey for Viking raiders. The first recorded attack on the monastery took place in 795, and there were subsequent raids in 802 and 806. The last of these was particularly serious, resulting in the slaughter of 68 monks. The chances of survival on Iona itself seemed slender and the decision was taken to transfer the community to a safe haven in Ireland. In 804, land had been granted at Kells, in the province of Meath, and a new monastery church was completed there by 814. At this point, the abbot of Iona journeyed across to Ireland, accompanied no doubt by many of the monastery's remaining assets.

Using a somewhat romantic interpretation of these events, some authorities have constructed a dramatic scenario for the Book of Kells. It was begun at Iona, so the argument goes, in the closing years of the 8th century. With the arrival of the Vikings, however, work on the manuscript came to a halt and was never resumed. Perhaps the artists responsible for the illuminations were among those slain in 806. Then, at a later date, the book was transported across to Kells, where it found a permanent home.

This sequence of events is perfectly feasible. Among other things, it would explain why the decoration of the manuscript was never completed, even though it had reached such an advanced state. The real truth, though, can never be known. It is just as plausible, for example, that the book was produced at Iona before the raids began, and was left unfinished for entirely different reasons. It was not unusual for manuscript projects, especially ambitious ones, to be abandoned in this way. Equally, it is

possible that the evacuation of Iona was not as drastic as is sometimes thought, and that work on the manuscript continued there after 814. Entries in both the Annals of Ulster and the Chronicon Scottorum suggest that Columba's relics may have remained at Iona until as late as 878. Or again, it may be that the book was actually produced at Kells, once the scriptorium from Iona had settled there. Supporters of this theory sometimes argue that the original purpose of the manuscript was to celebrate this transfer.

There have even been suggestions that the book was made on the British mainland, either at Lindisfarne or in eastern Scotland. This view is based primarily on the marked affinity

Detail of Breves causae, fol. 19v.

between Pictish stonework and some of the designs in the Book of Kells. There does appear to be a link, but the precise relationship between the two is very unclear and might well be explained by manuscripts that are now lost to us. In addition, it is hard to see how such a precious object would then have found its way to Ireland. For, whatever its origins, it is clear that the manuscript was firmly lodged at Kells by the 11th century.

This can be deduced not only from the theft of the book in 1006–7, but also from a number of 11th- and 12th-century charters which were inscribed onto blank pages of the text. These relate to gifts of land, which had been bestowed upon the monastery. At the time, it was standard practice to preserve

Opposite: Psalter of Ricemarch.

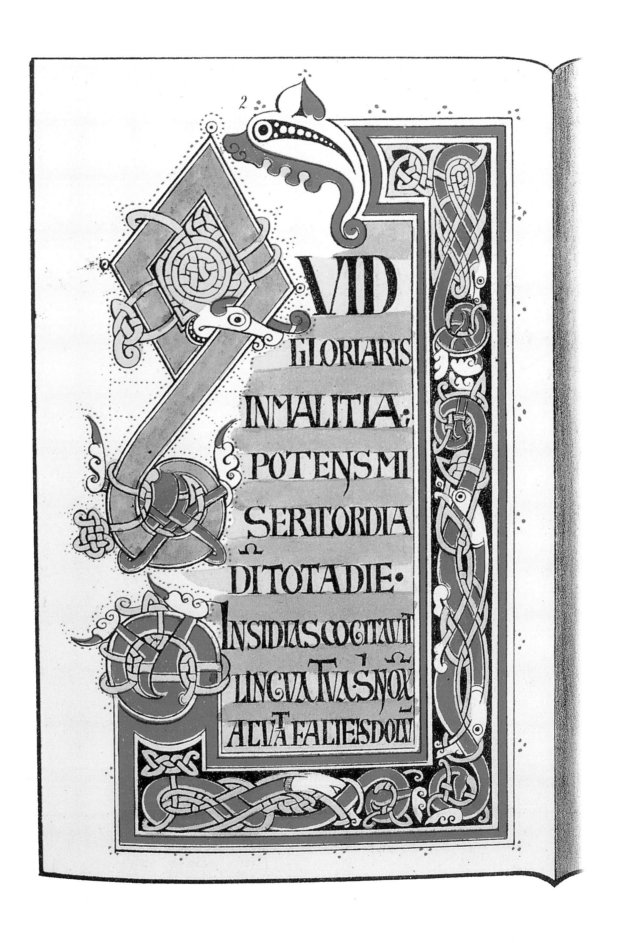

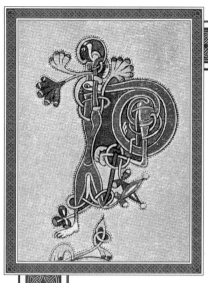

important documents in this way.

Throughout the Middle Ages, the manuscript remained undisturbed at Kells. The next upheaval occurred in 1539, during the Dissolution of the Monasteries, when the abbey of Kells was suppressed. According to official records, its goods and chattels then amounted to the paltry sum of £7 10s. It seems that the Book of Kells now passed into the possession of the last abbot, Richard Plunket. This would explain how a series of handwritten notes by Gerald Plunket, presumably a relative, came to be inserted in the manuscript later in the century. Further comments were added by James Ussher, Bishop of Meath, when he examined the volume in 1621. He counted the number of pages and wrote in some headings.

The book was finally donated to Trinity College, Dublin, in the mid-17th century. A report of 1665 described the sad remains at Kells, where horses were now stabled in the ruined church. It also added: 'The inhabitants of this town have for many hundred years past had the keeping of a large parchment manuscript in Irish, written as they say by Columkill's own hand, but of such a character that none of this age can read it.' The book, the report continued, had been sent to the commissioners of the Commonwealth. A letter of 1681 confirms the truth of this, revealing that the Book of Kells was given to Trinity College by Henry Jones, who had served in Oliver Cromwell's army in Ireland and was appointed Bishop of Meath in 1661.

The manuscript has remained at Trinity College ever since, although its unique qualities were not fully appreciated until the 19th century. Among other indignities, it suffered a disastrous rebinding in the 18th century, when an incompetent bookbinder trimmed off the edges of some of its illuminated pages, and it was mislaid for a time at the start of the following century. By the 1840s, however, it had taken its rightful place in the Long Room of the library. Queen Victoria saw it there in 1849, when it was described to her as 'St Columba's book'. The manuscript was rebound once again in 1953, when it was rearranged into four volumes, two of which are on permanent display in the Long Room.

RELIGIOUS AND DECORATIVE THEMES

For reasons that are no longer clear to us, the Book of Kells was never completed. In several parts of the manuscript, there are blank pages where, presumably, an illustration was planned. In others, tiny details are missing. On fol. 29r, for example, an angel's face has been omitted while, at the top of fol. 188r, a beast is poised to clamp a human head between its jaws, but only the man's tunic has been depicted. In addition, the manuscript suffered further damage during its long and turbulent history. Some pages were probably destroyed, when the book's cover was stolen, and further sheets were misplaced as a result of careless rebindings. In all, it is estimated that some 30 folios (60 pages) have been lost, out of the original total of around 370. Despite these various lacunae, it is possible to piece together the overall scheme of the decoration in the book.

In essence, it seems likely that the start of each of the Gospels was to be marked by three pages of full-length decoration: a page with the symbols of the four Evangelists, a portrait of the relevant saint, and an Initial Page with the opening words of the Gospel. Three ornamental pages were also to

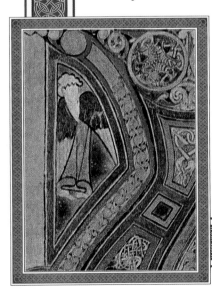

Unfinished Angel, Initial Page, fol. 29r.

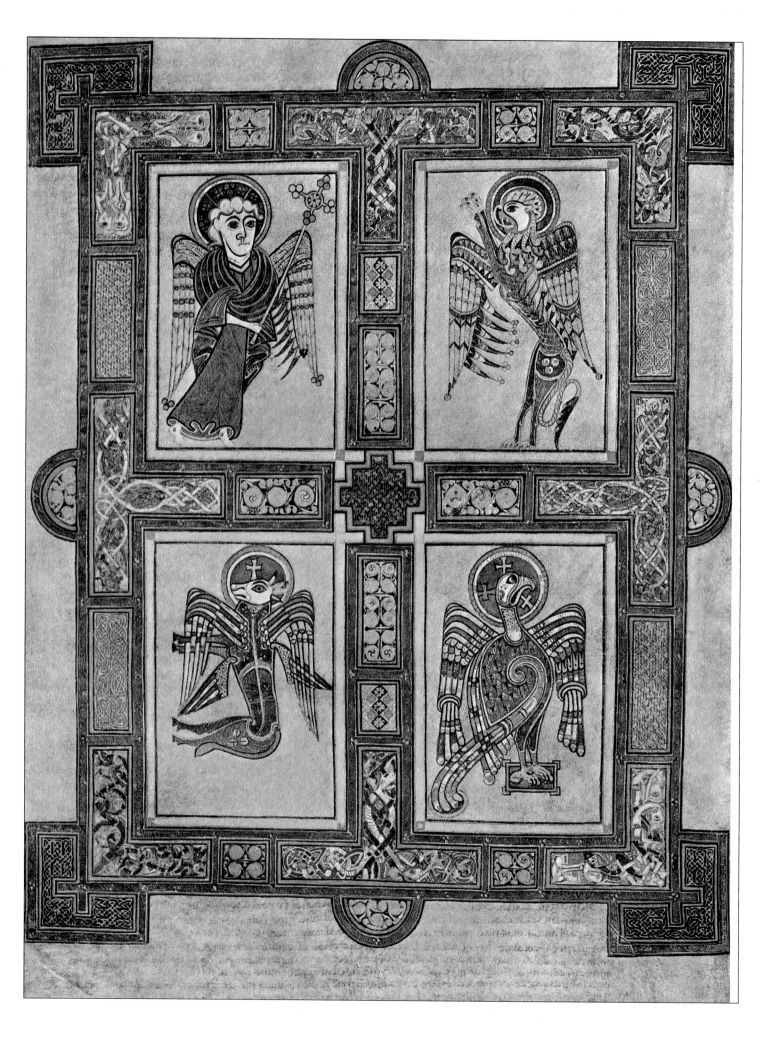

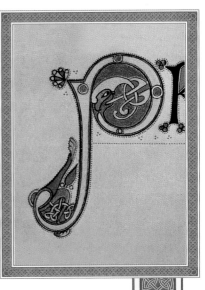

be located near the start of St Matthew's Gospel, at the passage dealing with the incarnation of Christ. In addition, there were to be a number of full-page illustrations, portraying important events in the life of Christ. Three of these have survived, but others may have been intended.

The Symbols of the Evangelists

The dominant motifs throughout the Book of Kells were the symbols of the four Evangelists. Three full-page illustrations were devoted to them and they also appear at the head of some Canon Tables, in the portraits of the individual Evangelists, and as marginal decoration on other pages of text.

The symbols were a staple feature of most early Gospel Books and comparable examples can be found in the Book of Armagh, the Book of Durrow, and the MacDurnan Gospels. In no other manuscript, however, is there such an overwhelming emphasis on these potent images. Where most Gospel Books devoted just a single page to the symbols, the Book of Kells has three (fols. 27v, 129v and 290v) and probably once had a fourth, which has now disappeared. Equally, it is safe to

Opposite: Evangelist Symbols, fol. 27v.

assume that the symbols would have figured largely on the missing illustrations of St Mark and St Luke. They can even be found on the very first page of the volume, crammed into two tiny compartments, opposite a glossary of Hebrew names.

The symbols have their origins in the Bible. They were mentioned in the prophecy of Ezekiel (Ezek. I, 10) and also in the Book of Revelation (Rev. IV, 6–9). In the latter, they were described as apocalyptic beasts, worshipping before the throne of God: '... and round about the throne were four beasts, full of eyes before and behind. And the first beast was like a lion, and the second beast like a calf, and the third beast had a face as a man, and the fourth beast was like a flying eagle. And the four beasts had each of them six wings about him; and they were full of eyes within; and they rest not day and night, saying Holy, holy, holy, Lord God Almighty ...'

These beasts were associated with the Evangelists at an early stage of Church history. The conventional attribution of each symbol was fixed by St Jerome (331–420). He linked Matthew with the

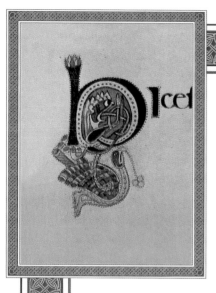

winged man, Mark with the lion, Luke with the ox or calf, and John with the eagle. The precise meaning of the imagery is far from clear, however, and many different interpretations have been proposed. One popular suggestion is that the creatures are linked with four important aspects of Christ's existence. According to this theory, the man relates to the Nativity, when He took on human form; the lion represents His royalty and majesty; the calf – a traditional sacrificial animal – refers to His role as the Saviour of mankind; and the soaring eagle is linked with the Ascension.

The portrayal of the beasts offered Celtic artists a fine opportunity to exercise their powers of invention. Certainly, this is true in the Book of

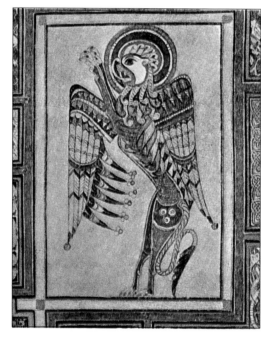

St Mark's Symbol, fol. 27v.

Kells, where the animals are portrayed in a variety of ways. On the first of the symbol pages, their sanctity is emphasised. Each of the creatures bears a halo and is winged. The haloes are all different – the three crosses in the eagle's nimbus, for example, represent the Trinity – and the calf and the eagle both have four wings, rather than the customary two. It is notable, too, that the eagle is perched on a cushion. This appears to echo a practice that was common in Byzantine religious art. There, sacred figures were often depicted with their feet raised off the ground, resting on cushions or stools, to underline their divinity.

In addition, the vertical format suggests that the artist may have intended the figures to be zoanthropomorphic, that is to say, combining animal heads with an

Opposite: Evangelist Symbols, fol. 129v.

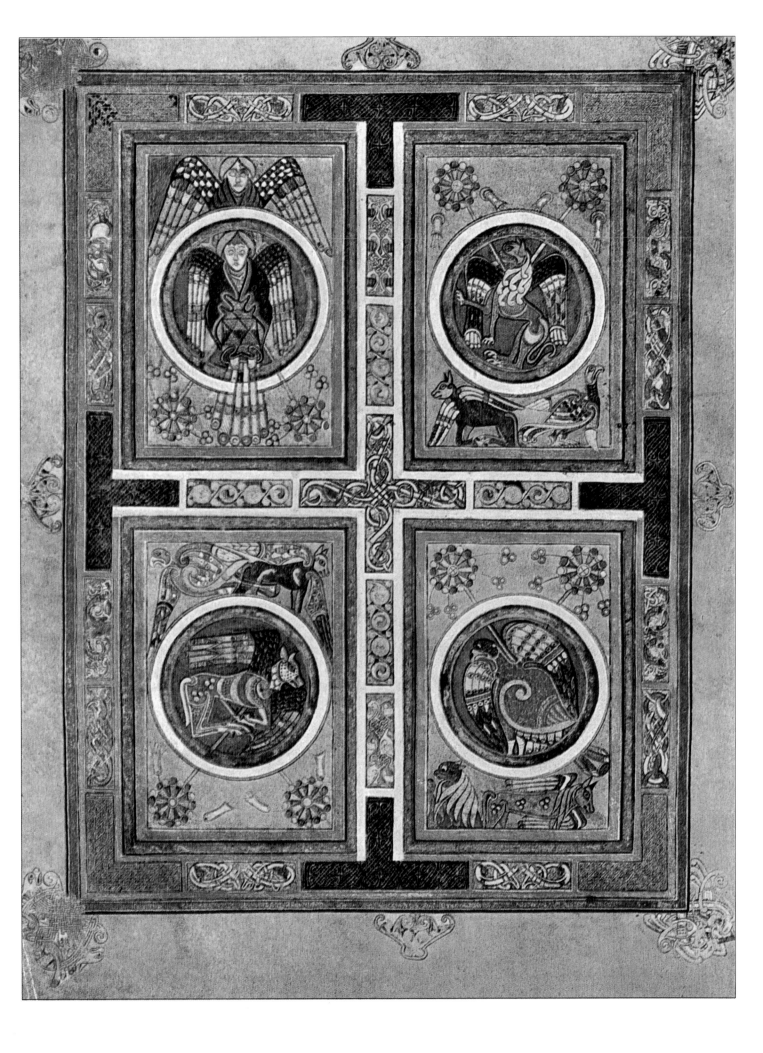

upright, human stance. This approach had been adopted on the symbol pages of earlier Gospel Books, and is clearly evident on an object like the Soiscél Molaise. The Kells' artist was certainly not averse to this type of imagery; he had already used it in the corner of one of the Canon Tables, where St John's eagle was shown holding a copy of the Gospel in a human hand.

In other illustrations, the emblems of the Evangelists are used in a more decorative fashion. In some Canon Tables, the beasts' wings are turned into framing devices (e.g. fol. 5r) while, in at least one of the symbol pages (fol. 290v), the creatures play second fiddle to a striking diamond and cross design. In the remaining illustration, the artist reverts to a format of four simple rectangles, but this time the symbols are placed inside yellow roundels. These may be intended to represent enlarged haloes. Each of the creatures is clutching a pair of extravagant fans and is accompanied by one or more of the other symbols. The constant intermingling of the Evangelists' emblems is a recurring theme throughout the Book of Kells, and is meant to stress the unity of the Gospels.

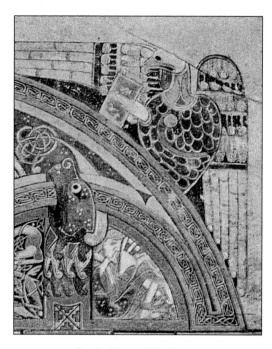

Detail of Canon Table, fol. 5r.

The Portraits

By the time that the Kells manuscript was created, it was normal practice to mark the opening of each Gospel with a portrait of the relevant Evangelist. Two of these have survived in the Book of Kells, along with a third portrait which probably represents Christ. These depictions of the Evangelists were modelled on the

Opposite: Portrait of St Matthew, fol. 28v.

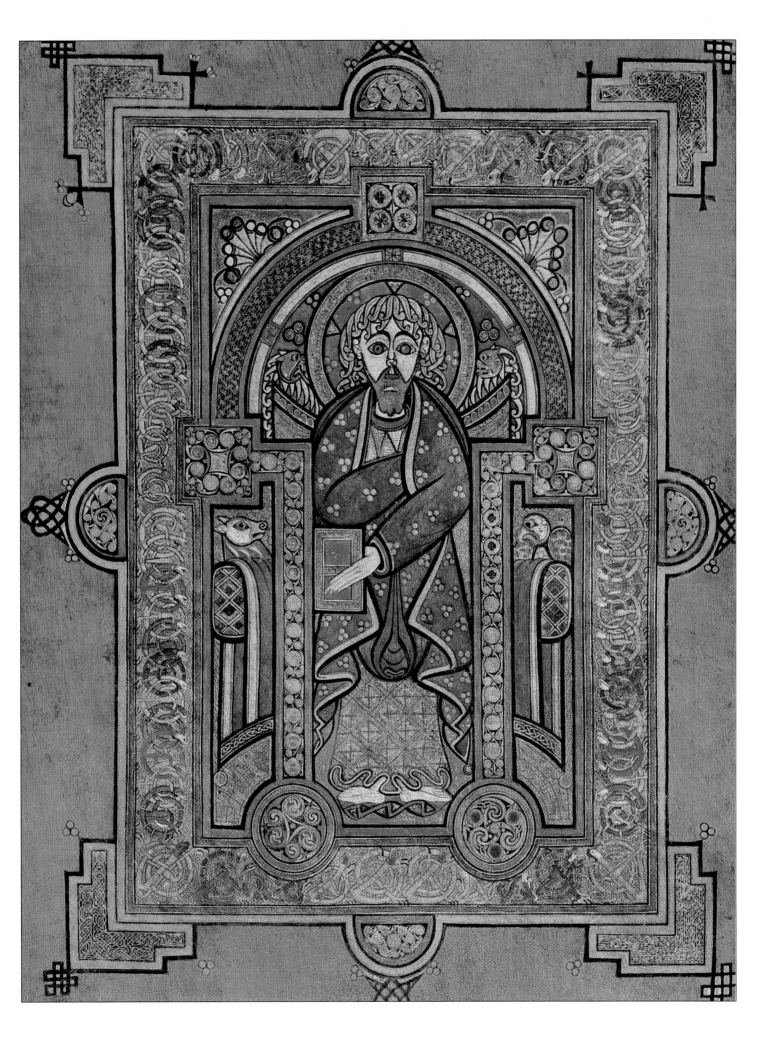

author portraits, which had appeared in manuscripts from the Late Antique period. In these, it was customary to portray the subject with a book and a pen and, in some instances, he was actually shown working on his text. A number of Classical portraits also depicted the author with a personification of his muse. The latter was usually located in a niche at the top of the picture, looking down and imparting ideas to the industrious scribe. Early Christian artists adopted this format, but replaced the muse with the relevant Evangelist's symbol. With an animal form, however, it was much harder to convey the idea of inspiration and, in many cases, the symbol seemed to provide little more than confirmation of the saint's identity.

The figure of St Matthew (fol. 28v), is the most conventional of the three Kells portraits. The saint is posed stiffly in front of a high-backed throne. In his left hand, he presents a book – a copy of his Gospel – and, around him, the symbols of the other three Evangelists are shown. Two lions' heads can be seen at the top of the throne, while the eagle and calf are positioned behind elaborate arm-rests.

At first glance, these arm-rests may appear to have been separated from the throne and placed in side compartments. In fact, however, the curious rectangles on either side are misconceived columns. In early author portraits, the subject was frequently shown sitting in a shallow niche, flanked on either side by columns. The idea was imported into Britain from Italy and its influence can be seen quite clearly in the portrait of St Luke, which features in the 6th-century Gospels of St Augustine and St Cuthbert. Celtic artists readily adopted this style of composition but, as they were not familiar with the architectural forms and were unaccustomed to the portrayal of space and perspective, they encountered obvious difficulties. As a result, they tended to flatten out the rounded architectural details and use them to create a profusion of abstract patterns. Thus, in the St Matthew miniature, the shafts of the columns have become nothing more than the sides of two rectangles. Within their borders, a delicate spiral design still evokes the effect of marble. Below, the

St Luke, Gospels of St Augustine and St Cuthbert.

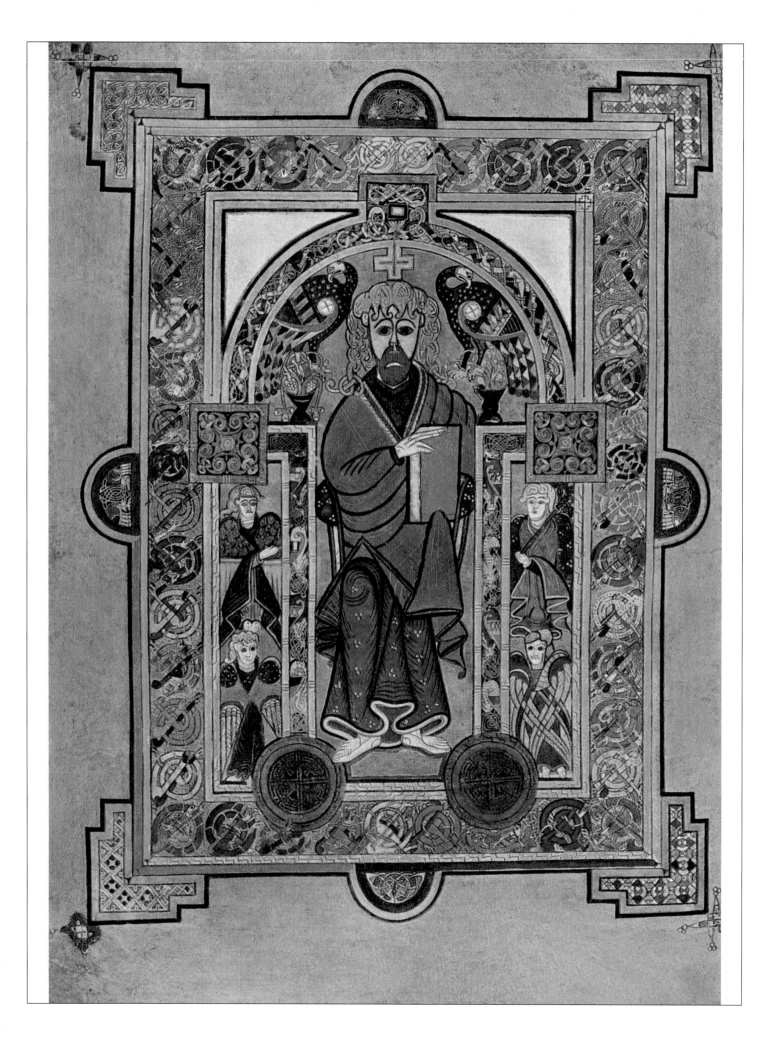

bases of the columns have been turned into two-dimensional roundels while, higher up, the capitals have been transformed into squares and pushed to the side of the picture. A third cube, situated above the saint's head, was once the keystone of the arch.

As architecture, the backgrounds of this and the portrait which follows it (fol. 32v) make no sense. The columns are far too short, extending no

higher than the shoulders of the Evangelists, and the heads of the two men are effectively positioned in the typanum. Despite this, some faint memories of the original structure have survived. In the second portrait, the flattened columns are still deemed solid enough to support the

weight of the chalices with vines.

The second portrait appears near the end of Chapter I of Matthew's Gospel. Some commentators have identified this as one of the missing Evangelist portraits and have argued that the page was inserted in the wrong place when the Book of Kells was rebound. According to this theory, the picture should appear at the start of either Mark's or Luke's Gospel. The more popular view, however, is that this is an illustration of Christ, with four angels in attendance. The latter are sometimes identified as the four main archangels – Michael, Gabriel, Raphael, and Uriel.

Portraits of Christ are rare in the early Gospel Books, but this section of Matthew's Gospel

Details of Portrait of Christ, fol. 32v.

Opposite: Portrait of Christ, fol. 32v.

would be an obvious place to include one. It coincides with an important passage describing the genealogy and incarnation of Jesus. In Kells, as in most other Gospel Books, this point in the narrative was highlighted with an elaborate Monogram Page (fol. 34r). Here, the significance of the passage is further underlined by the presence of the only Carpet Page (fol. 33r) in the manuscript. In addition, the symbols on either side of the figure's head refer to Christ's sacrifice, rather than to the Evangelists. In early Christian art, the peacock was frequently used as an emblem of the Resurrection and eternal life. This association derived from an ancient legend, mentioned by St Augustine in his City of God, that the flesh of the bird never decayed. The vines, which sprout from the chalices underneath the peacocks, also relate to Christ. They evoke the biblical passage which begins: 'I am the true vine ...' (John XV, 1-5) and they refer indirectly to Communion wine.

The finest of the Kells' portraits represents St John (fol. 291v). In many ways, he comes closest to the traditional notion of an author portrait. In his left hand, he displays his Gospel and in the other a long, tapering pen. Near his right foot, an inkhorn is lodged in the ground and John lowers his hand in order to dip the pen into it. The saint's throne may appear comparatively modest, in comparison with examples in other Celtic manuscripts, but there is ample compensation in the magnificent nimbus, which glows like a huge kaleidoscope around his head. John's splay-legged posture is a trifle ungainly, but it does at least emphasise that he is sitting down. In an age where the laws of perspective had yet to be defined, artists often found it hard to depict seated figures from the front. Compare this picture with the portraits of the Virgin and Christ. In the former, there is a clumsy attempt to combine a side view of the lower half of the body with a frontal view of the top. The portrait of Christ is more ambiguous. At first glance, He appears to be standing, but the heavy outline around the right knee suggests that the artist was actually trying to convey a seated position.

Opposite: Portrait of St John, fol. 291v.

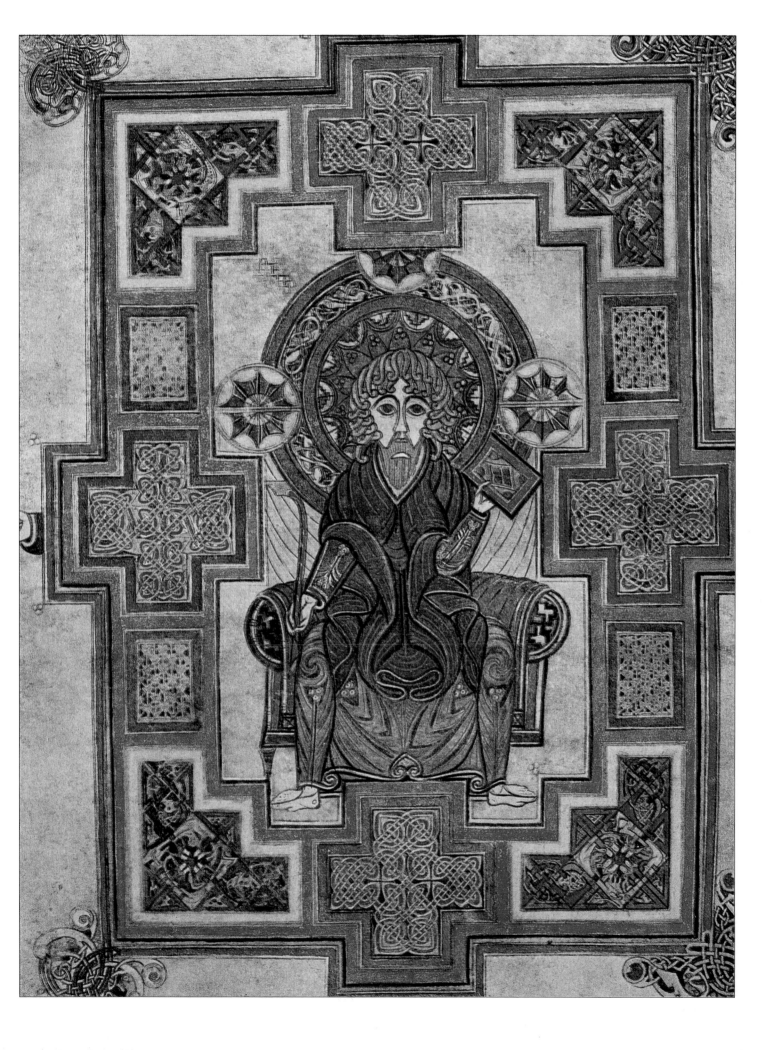

John's portrait is also remarkable for its elaborate symbolism. According to the Gospels, he was the only one of the Evangelists to be present at the Crucifixion and he was always given a prominent role in later portrayals of the sacred event. Even at this early stage, John's close association with the Crucifixion is perfectly plain. The limbs and head of a figure (the latter sadly mutilated by an incompetent binder) can be seen protruding from the four sides of the border. This figure does not bear the marks of crucifixion but, with its outstretched arms, it is clearly meant to evoke the shape of the Cross. The same theme is echoed within the border decoration. Four crosses bisect the sides of the border and, within these, there are subtle hints of smaller crosses. At the top and bottom, for example, the interlace pattern conjures up an image of four identical crosses, all converging on a single point at the centre. This interplay between symbolism and decoration is one of the outstanding features of the Book of Kells.

The Illustrations

In some ways, the use of narrative illustrations is one of the most revolutionary aspects of the Kells manuscript. Although not entirely without precedent, the practice of inserting miniatures of this kind into the main body of the text was extremely rare. A few Eastern examples are known, most notably the Rabbula Gospels of 586, but only one other Western manuscript has been traced. This seems to mark a new phase in the development of Celtic art. For, even though the figures in the illustrations are still extremely stylized, they do appear to reflect a growing interest in figurative composition. This runs parallel with a trend that can be detected on the Celtic crosses of the period. Here too, the decoration on early examples had been almost exclusively abstract, consisting of the usual medley of spirals, knotwork and interlacing. Gradually, however, these were superseded on the spectacular Crosses of the Scriptures, where ornamental patterns gave way to scenes from the Bible.

Three full-page illustrations have survived in the Book of Kells, representing the Virgin and Child (fol. 7v), the Arrest (fol. 114r), and the

Temptation of Christ (fol. 202v). Many authorities believe that further scenes were either planned or have since been lost. If so, the most likely subjects would have been a Crucifixion, a Last Judgment, or an Ascension.

The first of the existing illustrations, the portrayal of the Virgin and Child, appears near the start of St Matthew's Gospel and was intended to accompany the description of the Nativity. The theme was to become enormously popular in the Middle Ages, but this is the earliest known example in an Insular manuscript. As a result, the source of the image has attracted widespread speculation.

The most commonly held view is that the composition stems ultimately from a Byzantine icon. The Virgin and Child was a favourite theme in the East, with a tradition dating back several centuries. During this time, icon-painters had developed a number of specific conventions, some of which are reproduced in this miniature. The Kells Madonna wears a maphorion (a Greek robe) and a stylized, star-shaped brooch, both of which were normally featured on Eastern versions of the subject.

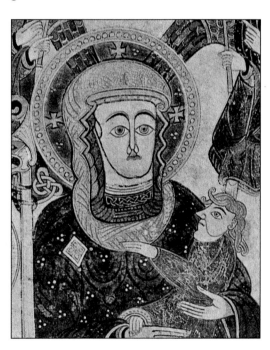

Detail of The Virgin and Child. fol. 7v.

The pose is more complex, as it appears to combine two separate formats. Icon-painters made a distinction between the Elousa or merciful type of Madonna and the more severe Hodegetria form. The former emphasised the affectionate, maternal relationship that existed between the two figures. Here, this is evident from the tender gestures of the hands and the loving way in which Christ looks up at His mother.

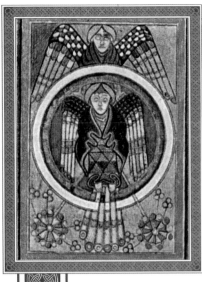

formats. Icon-painters made a distinction between the Elousa or merciful type of Madonna and the more severe Hodegetria form. The former emphasised the affectionate, maternal relationship that existed between the two figures. Here, this is evident from the tender gestures of the hands and the loving way in which Christ looks up at His mother. By contrast, the Hodegetria format was designed to highlight the Virgin's role as *theotokos* or god-bearing. In this type of image, both the mother and child would be shown frontally, gazing out at the viewer with a cold, hieratic stare. In addition, the Infant Christ would appear unusually mature for His years. Some elements of this are present in the Kells miniature, but the effect is undermined by the affectionate manner of the Child. The prominent outline of the Virgin's breasts also raises the possibility that the artist had seen a picture of the Madonna suckling the infant Christ, and was trying to adapt the theme for

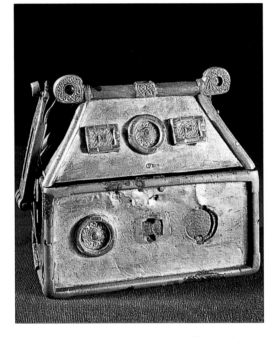

The Monymusk reliquary contained relics of Saint Columba.

Western audiences, by cloaking the Virgin in modesty.

Many observers have also commented on the curious devices that the angels are holding. One carries a flowering bough, while the other three have rods with discs. Similar implements are carried, either by angels or by the symbols of the Evangelists, in other sections of the manuscript. They may represent sceptres or, more probably, flabella. The flabellum was a liturgical fan, which was used by deacons in the Eastern Church to keep flies and other insects away from the altar. In the cooler climate of the

British Isles, such items were scarcely necessary, but they were still frequently included in collections of liturgical equipment. It is known, for example, that St Columba owned one. Adomnan mentioned that it was preserved among his relics and later records show that it survived until 1034, when it was accidentally lost at sea. The flabellum could take a number of different forms – sometimes composed of peacock feathers and sometimes of metal discs – and its use as a general symbol for purity is especially appropriate here.

Despite the Eastern flavour of the Virgin and her attendants, the character of the surrounding details is entirely Celtic. The animal interlacing in the borders and the beard-tugging figures in the semicircular insets were common motifs in both the metalwork and stonework of the period. These secular features even encroach upon the figure

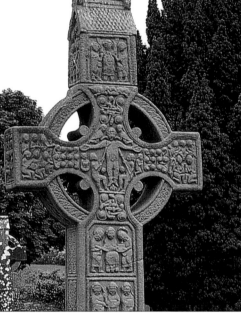

The arrest of Christ, on a cross at Monasterboice, Ireland.

of the Virgin herself. At her throat, there is a typically Celtic knotwork pattern while, nearby, a fierce animal head sprouts from the top of her throne and coils its tongue around the backrest.

The subjects of the remaining illustrations are far less common in Western art and offer little basis for comparison. The Arrest (fol. 114r) appears near the end of St Matthew's Gospel and is accompanied by a brief text: 'Et ymno dicto exierunt in montem Oliveta' ('And when they had sung a hymn, they went out into the Mount of Olives'; Matt. XXVI, 30). The scene portrays a massive Christ, held prisoner by two bearded minions. Above, the violence of the scene is echoed by two snarling beasts, whose tongues are interlaced. This motif was

position, hints at the approaching Crucifixion. In the same way, the curling vines in the upper part of the miniature probably refer to the Eucharist. It is true that the Kells artist might have known from Adomnan's book on sites in the Holy Land that the real Mount of Olives was covered in vines and olive trees. Even so, it is scarcely likely that the plant would have been given such prominence for purely descriptive reasons. The tendrils are carefully positioned so that they frame Christ's head, rather like a leafy halo. They also sprout from chalice-like containers, just as they do in the portrait of Christ, where their symbolic meaning is clear.

The Temptation of Christ (fol. 202v) is an equally idiosyncratic composition. It appears near the start of St Luke's Gospel and illustrates the third of the temptations, when Satan carried Christ up to the pinnacle of the temple in Jerusalem and delivered his challenge. 'If thou be the Son of God, cast thyself down from hence. For it is written, He shall give his angels charge over thee, to keep thee. And in their hands they shall bear thee up, lest at any time thou dash thy foot against a stone' (Luke IV, 9–11).

This scene has been depicted in an unusually literal fashion. A youthful Christ is portrayed half-length, looming over the roof of the temple. Above, four angels wait in readiness. Two are poised to catch Christ, in case He should fall, while the others are displayed in triangular compartments at the top of the picture. These compartments also contain the chalices with sprouting vine tendrils, which are featured in other miniatures of Christ. The artist has had to use some ingenuity to fit these elements into the limited space and, in one instance, the chalice is on its side, with the vine spiralling downwards. On the right of the scene, a smoky black devil attempts to weave his spell. He has few counterparts in Western art, but similar demons were featured in Byzantine manuscripts and mosaics. As in the Arrest, the forces of evil seem frail and insignificant beside the massive figure of Christ.

The colourful structure of the temple has aroused much discussion. It does not resemble any known building, but there are strong links with two other forms of Christian artwork. Comparisons have been made with the

house-shaped shrines, such as the Monymusk Reliquary or the Emly Shrine, which were popular with Celtic craftsmen. Similar structures can also be found at the top of many Celtic crosses. As always, there is no certain way of knowing which medium influenced the other but, in this instance, the figure in the temple doorway may offer a clue. The crossed sceptres suggest that the detail was taken from a depiction of Christ in Majesty. Such a theme would have no special relevance here, but it was frequently portrayed on the wheel of a Celtic cross. It seems plausible, therefore, that the painter of this miniature drew some of his inspiration from an example of stonework.

The inclusion of three groups of profile heads is much more puzzling. Nobody has produced an entirely satisfactory explanation for their presence. In the context of the Gospel narrative, they might possibly refer to the passage which follows the Temptation, when Jesus went out to preach in the area around Galilee.

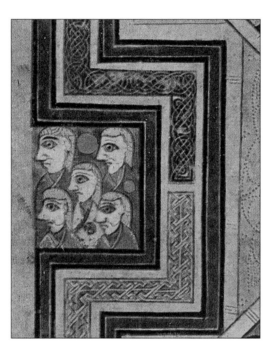

Detail of Crucifixion Page, fol. 124r.

As such, they might represent the crowds who came to hear him talk. Even so, it is notable that similar heads appear on other pages – the scene with the Crucifixion page, for example – where the same interpretation would not be possible. It may well be that no specific meaning was intended.

Initial Pages

Unusual though they are, the narrative illustrations are probably less well-known than the various pages of calligraphy. For, it was on sections such as these, that the Celtic genius for ornamental design came into its own.

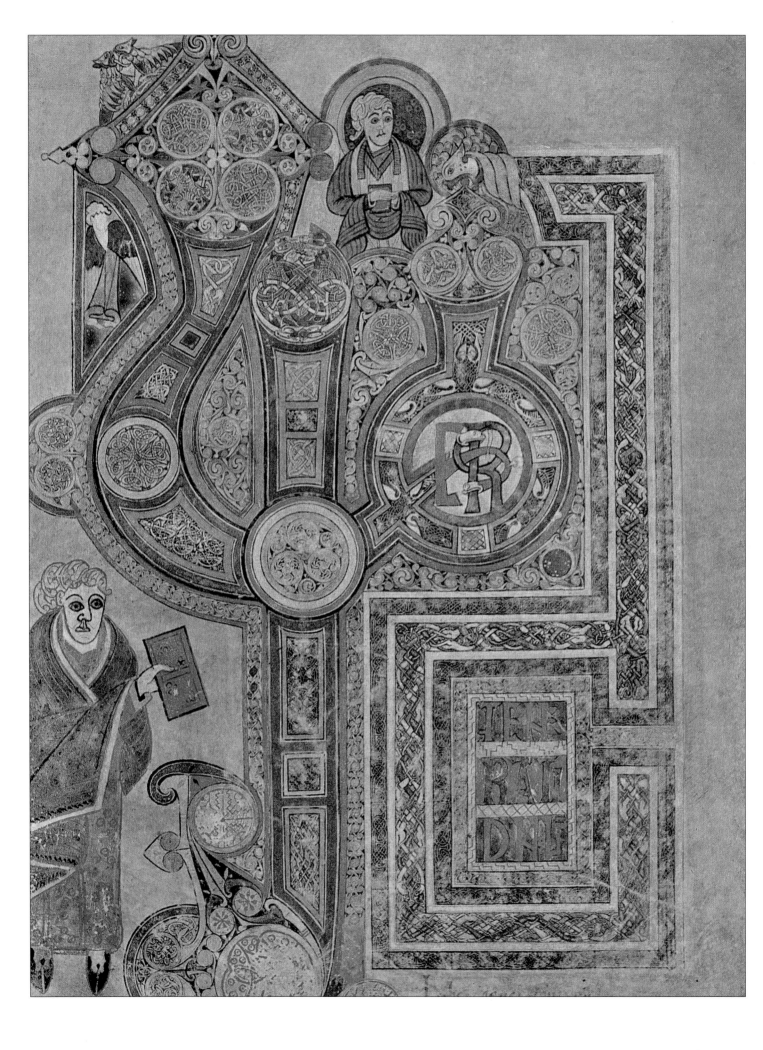

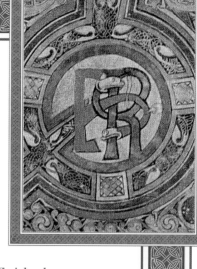

Initial Pages had been given special prominence in most of the earlier Gospel Books, but none had been quite as elaborate as these. In most cases, the mood of the decoration is so exuberant that the artist only managed to fit two or three words onto a single page.

St Matthew's Gospel opens with the phrase 'Liber generationis' ('The book of the generation ...'; fol. 29r) and this is fittingly employed as the chief motif in the miniature. Two separate characters display the Gospel for us. The figure at the top is probably the saint, standing in front of a halo-like sphere. The identity of the larger figure is a mystery. Some have claimed that it is a later addition, used to fill up a gap in the composition. Certainly, it is true that this page was never completed . properly. The most obvious gaps can be seen in the upper left-hand corner,

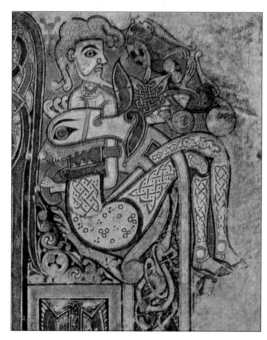

Detail above: Initial Page of St Mark's Gospel, fol. 130r.

Opposite: Initial Page of St Matthew's Gospel, fol. 29r.

where an angel's face and part of the border have not been painted in, and on the right, where the roundel containing the letters 'ER' has been left half-finished.

The Initial Page for St Mark's Gospel (fol. 130r) is rather more difficult to decipher. It reads: 'Initium Evangelii Ihu Xpi' ('The beginning of the Gospel of Jesus Christ'). The last two words are standard contractions for Christ's name, while the 'n' of 'Initium' has been transformed so radically that it resembles a reversed 's'. The interiors of the letters and borders contain bird and animal interlacing of the most extraordinary kind, although none of

Following page: Initial Page of St Luke's Gospel, fol. 188r.

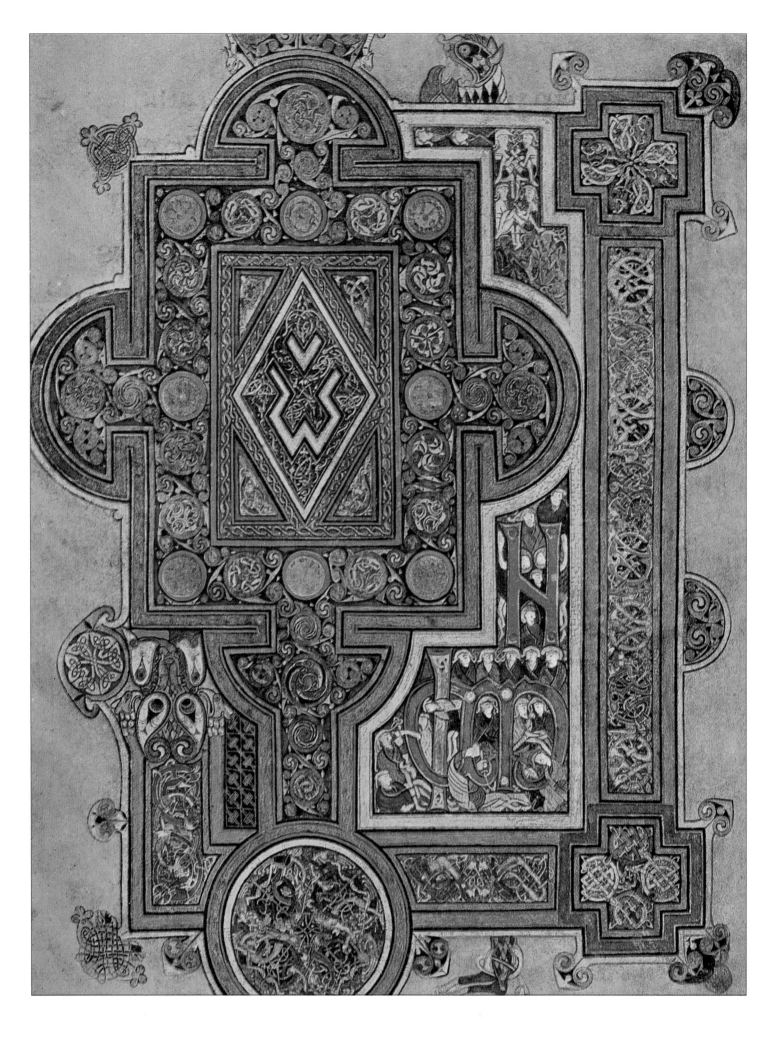

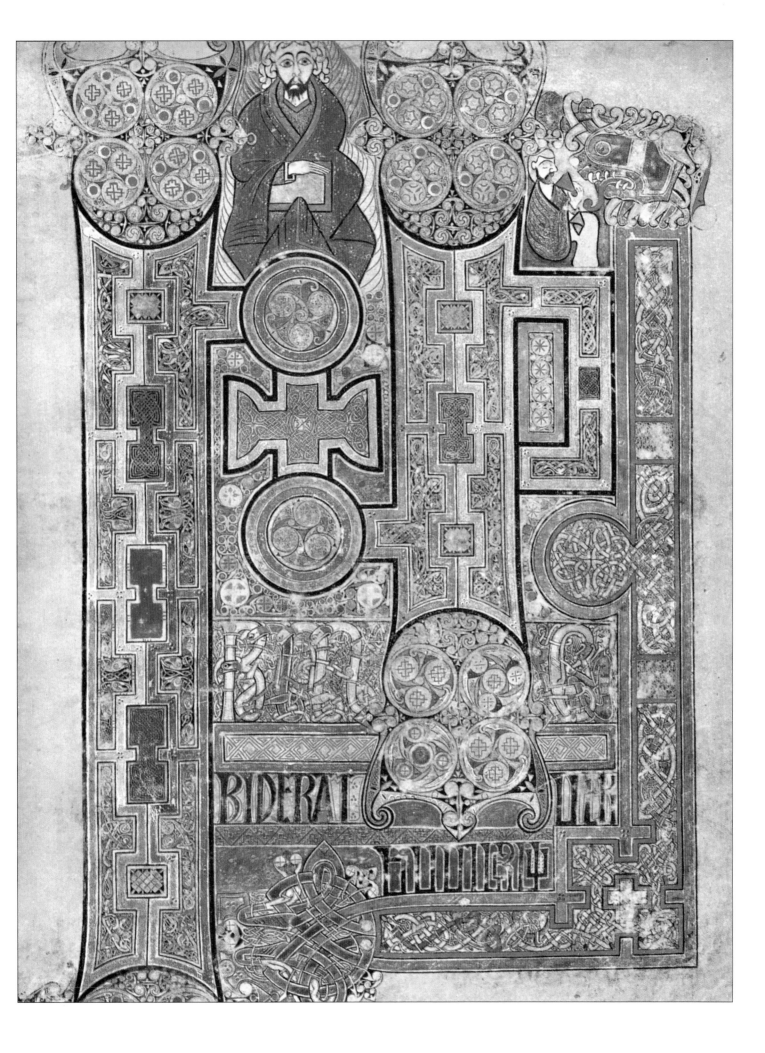

Ihu Xpi' ('The beginning of the Gospel of Jesus Christ'). The last two words are standard contractions for Christ's name, while the 'n' of 'Initium' has been transformed so radically that it resembles a reversed 's'. The interiors of the letters and borders contain bird and animal interlacing of the most extraordinary kind, although none of these surpasses the dramatic confrontation in the upper right-hand corner. There, an impassive, bearded fellow is trapped inside the jaws of a ferocious lion. Despite his dilemma, he grips the tongue of the beast in one hand and the tip of his own beard in the other. To complicate matters still further, the latter has become entwined with the tails of two symmetrical peacocks.

The introduction to St Luke's Gospel (fol. 188r) is probably the most elaborate of the series. It is taken up with just a single word, 'Quoniam' ('Whereas'), and much of the space is devoted exclusively to the

Above: Detail of top right of plate XIX - lion's head with man & chalice

Previous page: Initial Page of St John's Gospel, fol. 292r.

'Q'. Once again, the emphasis appears to be on suffering. At the top, a man's head is held tightly between the jaws of a lion – or it would be, if the artist had finished painting the figure in – and the beast's feet can be seen dangling beneath the border, at the foot of the page. The victim's fate is shared by two tiny figures in the lower right-hand corner. There, the mischief is performed by two lions' heads, which emerge from the terminals of the letter 'm'. The surrounding figures also seem to be languishing in pain, but no one has found an entirely convincing explanation for their plight. Some commentators argue that they may represent the torments of hell.

The last of the main Initial Pages illustrates the words: 'In Principio erat Verbum et Verbum' ('In the beginning was the Word and the Word ...'; fol. 292r). This contains a most attractive frieze of letters, the 'rinci' of 'Principio', which is composed of delicate animal interlacing. In addition, the 'c' and 'i' combine to form a man playing the harp, while the 'rin' which precedes it contains a chalice with sprouting vine leaves growing horizontally from right to left.

This allusion to the Eucharist is echoed in the upper right-hand corner, where a seated figure drinks from a chalice, unabashed by the open-mouthed beast which confronts him.

Incarnation Pages

The Initial Pages were not confined to the opening passages of the individual Gospels. Indeed, the best example of calligraphy and, arguably, the most spectacular page in the entire manuscript occurs within the main body of the text. This is the so-called Monogram Page (fol. 34r), which appears near the start of St Matthew's Gospel. After a lengthy preamble, in which Christ's descent from Abraham is listed in great detail, the Evangelist finally opens his account with the words: 'Now the birth of Jesus Christ was on this wise ...' (Matt. I, 18). For many, this marked the true beginning of the New Testament story and, accordingly, illuminators lavished the full range of their skills on it.

The Monogram Page was the highlight of many Celtic Gospel Books, but in no previous manuscript had this biblical passage received quite as much attention. For, in the Book of Kells, the incarnation of Christ was celebrated with three full-page illustrations. Firstly,

there was the portrait of Christ (fol. 32v), itself a considerable rarity in works of this kind. There then followed a Carpet Page (fol. 33r), the only one to be featured in the Kells manuscript, before the decoration reached its climax in the Monogram Page.

The entire page is taken up with just three words: 'Christi autem generatio'. These are actually transcribed as XPI and, in smaller writing at the bottom, H (the standard contraction for autem) Generatio. The XP or Chi-Rho is Christ's monogram, taken from the first two letters of His name in Greek. Even if one had known all this, however, the script itself must have seemed well nigh indecipherable to all but the initiated. Without doubt, this was intentional. To any illiterate outsider, it must have seemed little short of magical that anyone could form words out of such a seething mass of knots and spirals.

The Chi-Rho should not be regarded simply as a convenient abbreviation. At the time, it was regarded as a potent symbol of the Christian faith. In early Christian art, it was frequently carved

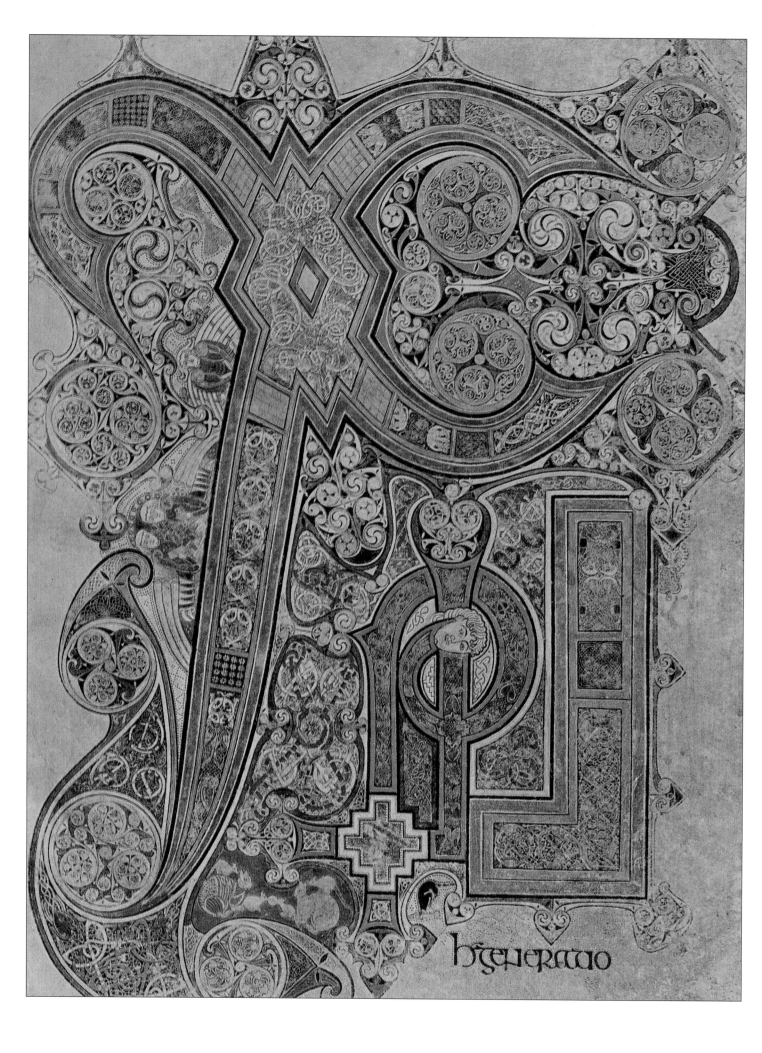

hgeneracio

mark their shields with the Chi-Rho and, in due course, he was rewarded with a resounding victory.

For modern observers, the Monogram Page is equally remarkable for the profusion of tiny figurative details, which are hidden away amid all the other decoration. The loop of the

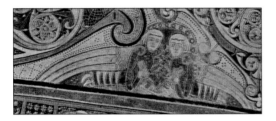

'P' terminates very obviously in the head of a man but, on the left-hand side of the picture, three angels are more cunningly concealed. Two of them hover lengthwise, their tiny feet dwarfed by the sleek curves of their enormous wings. In one hand, they each grip a book, representing the Word of God. Their other hands are entwined, together with parts of their costume. The third angel is located a little higher up on the 'X'. In his hands, he is holding miniature flowering rods, which are plaited together with the strands of his wings.

Above: Detail of Angels, Monogram Page, fol. 34r.

Opposite: Monogram Page, fol. 34r.

The same sheet also contains three charming animal scenes. Nestling

under the upper, left-hand curve of the 'X', there is a comparatively naturalistic depiction of two moths. Meanwhile, at the foot of the page, in between the 'X' and the 'P',

there is a more enigmatic scene featuring two pairs of mice and two cats. Finally, underneath the base of the 'P', there is a tiny depiction of an otter holding a fish in its mouth.

The question that arises with details of this kind is whether they are meant to be read symbolically or whether they are just skittish images, painted by the artist for his own amusement. The problem is virtually insoluble, since both attitudes seem to be in evidence in different parts of the manuscript. Nevertheless, given the importance of this particular page, it is reasonable to look for possible interpretations.

On the surface, the image of the otter and the fish seems to provide the clearest message. The fish was one of the most ancient Christian symbols. It was commonly scratched on the walls of the catacombs of Rome, during the early years of persecution. This association with Christ is thought to have come about because the Greek word for fish, ichthys, could be used as an acrostic for the phrase, 'Jesus Christ, the Son of God, Saviour'. In addition, the fish rapidly came to represent the sacramental meal and, since it is gripped in the jaws of an animal, it seems quite feasible that this is the intended allusion here.

The meaning of the other details is more obscure. It has been argued that the two moths are situated on opposite sides of a chrysalis. The latter would have obvious relevance here, on a page which deals with Christ's incarnation and birth, but the image of the chrysalis is too small to identify with any certainty. The vignette with mice, however, has provoked more controversy than any other aspect of this page. When examined in detail, it is clear that the two mice (or rats) at the centre are nibbling a communion

Opposite: Monogram Page, MacDurnan Gospels.

wafer. As they do so, their tails are trapped by the two cats behind them. These, in turn, have their ears bitten by two further rodents. Some have claimed that this is part of a large-scale programme of eucharistic symbolism, which is scattered throughout the entire Kells manuscript. Others maintain that it is simply a humorous comment on the difficulties of keeping pests away from the consecrated host. Technically, it would be a sacrilege, if an animal was able to consume the body of Christ. These conflicting arguments are finely balanced. It is undeniably true that the motifs of the chalice and the communion wafer recur frequently in the Book of Kells. At the same time, there is also concrete evidence that animal imagery could be employed in a religious context without any symbolic overtones. On Muiredach's Cross at Monasterboice, for example, the stonemason did not find it incongruous to introduce a pair of cats into an elaborate array of biblical scenes.

As with the Monogram Page, the chief aim of the Carpet Page

on fol. 33r was to impress the viewer. Indeed, it seems quite likely that the two leaves were originally designed to face each other. The trimmed edge of the Carpet Page suggests that it was inserted wrongly, during one of the manuscript's unfortunate rebinding programmes. If so, the pairing of the two most ornate pages in the entire book would have made an extremely impressive sight.

The concept of the Carpet Page had a long pedigree. It evolved out of the practice of prefacing the Gospels with the sign of the Cross. This dated back to the early Christian period and can be found in such works as the Glazier Codex, which was produced in c.500. Insular artists transformed this idea, by submerging the cross in a sea of decorative detail. As a result, the underlying symbolism sometimes became obscured. Here, for example, it may not be immediately apparent that the eight circles are meant to represent a double-barrelled cross.

Beyond this, Carpet Pages were purely ornamental and were largely composed of abstract or semi-abstract forms. The word 'carpet' derived from the extravagantly interwoven patterns, which suggested an affinity with textiles. This decorative effect may be easier to grasp in earlier manuscripts, such as the Book of Durrow and the Lindisfarne Gospels. In the Kells manuscript, the tightly compressed bands of interlacing reveal a different facet of the Celtic personality – a childlike delight in ambiguity and shape-shifting. If you look closely enough at the design, traces of human and animal features begin to appear. A wing, a tail, an eye emerge from the chaos and then vanish again. In the octagonal insets in the centre, there are shadowy hints of four bearded men, curled up like embryos. Each one is different. So, while one of them seems to be on the point of biting his own foot, his neighbour is hopelessly entangled with a vicious, sharp-billed bird. On no other page of the manuscript does the advice of Giraldus Cambrensis to 'look closely' and 'penetrate to the very shrine of art' seem so appropriate.

For all the intricacy of this design, however, there were signs that the taste for Carpet Pages was beginning to wane. There is only one such page in

Opposite: Carpet Page, fol. 33r.

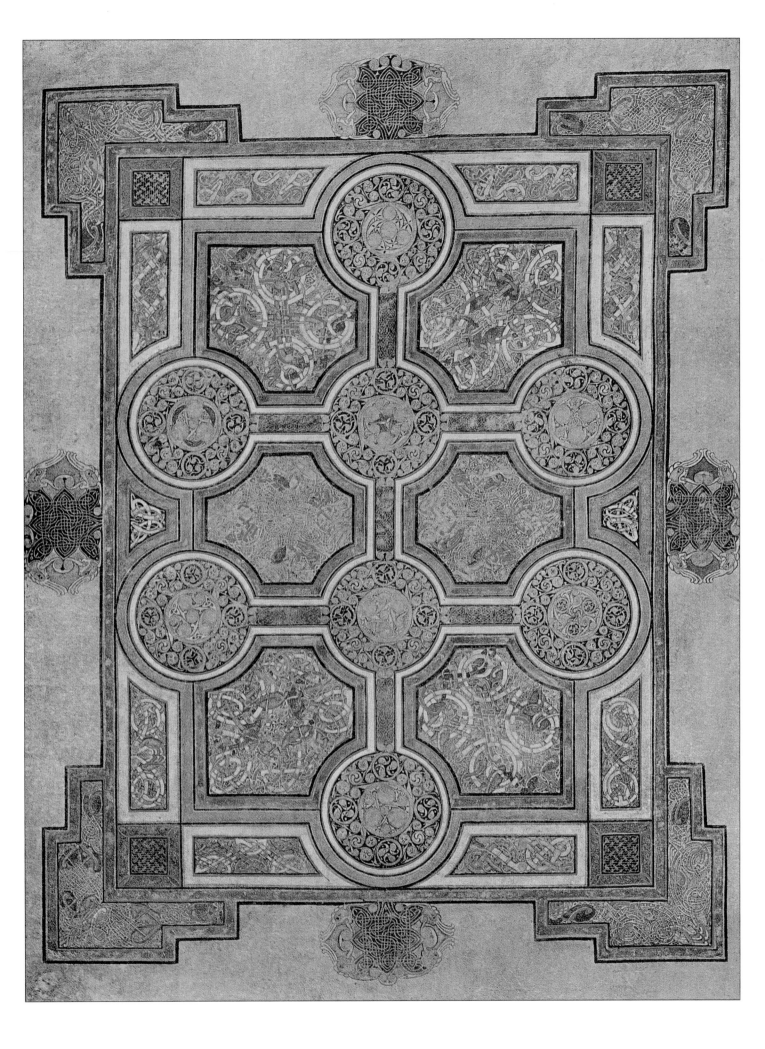

the Book of Kells, where some of its predecessors had included several. This decline would also accord well with the growing trend towards figuration, which was echoed in the field of stonework. As already mentioned, the scope for abstract pattern-making diminished, once artists turned their attention towards narrative illustration.

The Crucifixion Page

Another Initial Page can be found near the end of St. Matthew's Gospel. On fol. 124r, the words 'Tunc crucifixerant XPI cum eo duos latrones' ('Then were two thieves crucified with him'; Matt. XXVIII, 38) have been arranged into a striking design. Originally, this would have formed part of a highlighted section, similar in concept to the Incarnation

Detail of Carpet Page, fol. 33r.

Pages. Unfortunately, this plan was never realised and the facing page (fol. 123v) is blank. Almost certainly, this space was set aside for an illustration of the Crucifixion.

While it was standard practice for Celtic artists to make a special feature of the Incarnation passage in Matthew's Gospel, it is unusual to find the description of Christ's Passion being treated in such a lavish manner. A few illustrations of the Crucifixion have survived in early manuscripts, but there is no close parallel for this Initial Page. Indeed, its very rarity may account for the fact that the words are relatively easy to decipher. This would have been helpful, if the monks were unaccustomed to seeing such a design. Apart from the extravagance of the opening 'T', the only real distortion of

Opposite: Crucifixion Page, fol. 124r.

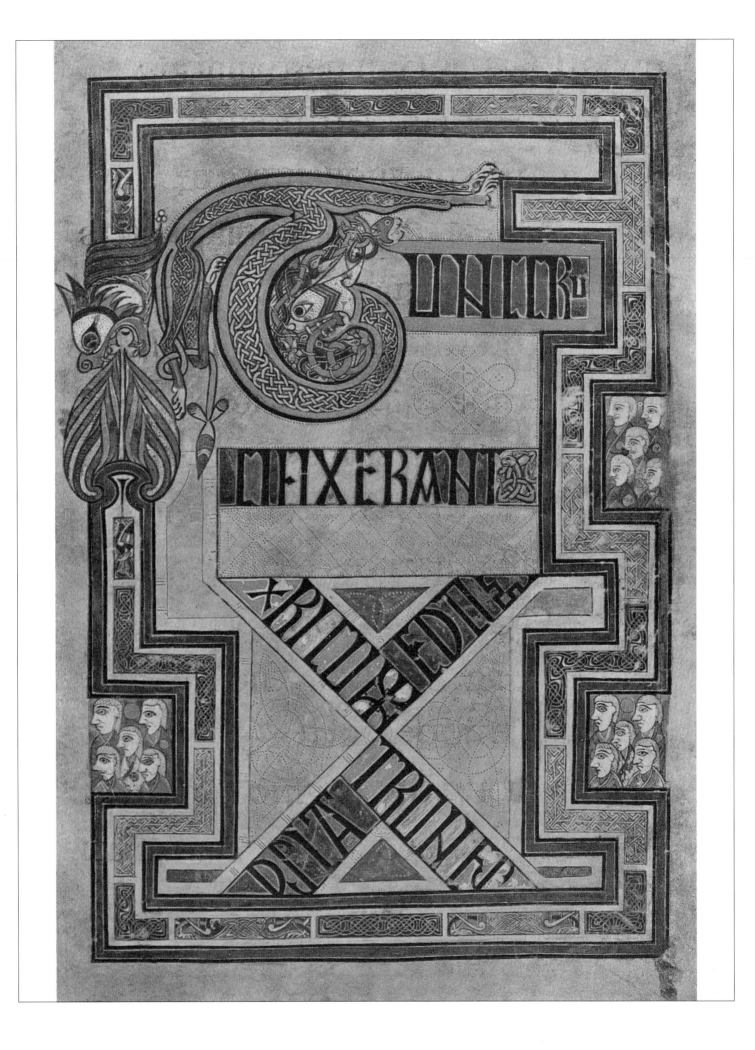

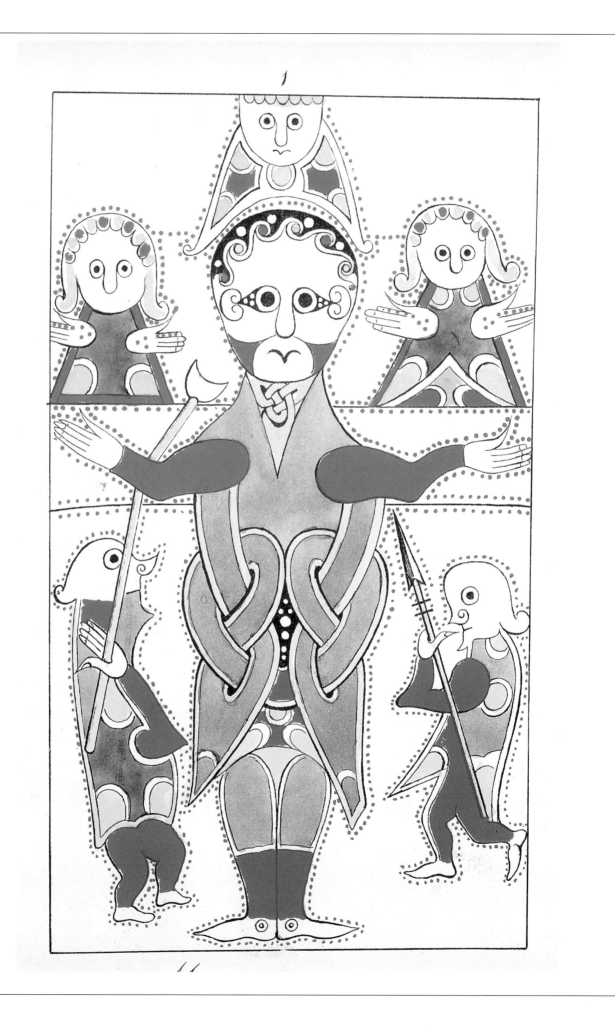

the text occurs in the lower part of the page, where the letters have been set into the shape of a diagonal cross. This motif has obvious relevance here, in the context of the Crucifixion.

The significance of the remaining elements on the page is much harder to determine. The most eye-catching features are the two lions, which dominate the border and the opening word of the text. Animal borders had been used in earlier Celtic manuscripts, often with comic effect. In the 'Quoniam' page in the Lindisfarne Gospels, for example, there is a border with a cat's head and a series of birds. Here, the humorous inference is that the cat has swallowed the birds, which are contained within its 'body' (i.e. the border). This playful approach is less apparent in the Book of Kells, even though interlaced birds and serpents are occasionally located inside borders. Instead, there is a greater emphasis on the transformation that occurs to the animal itself. In this case, the lion is chasing its own tail, which has changed into a pair of stylized peacock wings. The lion which forms the letter 'T' is also altered. Its tail turns into a vine

Opposite: Crucifixion, Southampton Psalter

tendril, identical to those which are featured in the Arrest of Christ (fol. 114r). This is quite different from the lion's normal tail, which can be seen in depictions of the Evangelists' symbols (e.g. fol. 27v).

Animal borders can be found elsewhere in the Book of Kells, though they are usually better disguised. On the opening leaves of St. Mark's and St. John's Gospels, the beast's head can be found in the upper right-hand corner and its tail appears at the foot of the page. At the start of St. Luke's Gospel, this format seems to have been reversed. An animal's head is located in the lower left-hand side of the border and the decoration in the upper right-hand corner of the page could be interpreted as its tail.

The abundance of lion heads in the Kells manuscript has led to speculation that they may have carried a further meaning for the illuminator, beyond their traditional association with St. Mark. It is true, for example, that the animal was sometimes linked with Christ. A passage in Revelations describes Him as 'the lion from the tribe of Judah' (Rev. V, 5). More

significantly, perhaps, the beast was also linked with the Resurrection. This came about because of a legend that every lion cub was born dead and only came to life after three days, when its father breathed on its face. However, the situation is complicated by the fact that the lion can also represent Satan. In the New Testament, for example, Christians are advised to be wary 'because your adversary the devil, as a roaring lion, walketh about, seeking whom he may devour' (I Peter V, 8). This passage certainly provides a more satisfactory explanation for the aggressive lions that appear on the Initial Pages of St. Luke's and St. John's Gospels.

Commentators have also been intrigued by the three groups of tiny figures, which gaze across to the left. These have obvious affinities with similar groups in the illustrations of the Virgin and Child and the Temptation of Christ. In this instance, it seems likely that they represent the Christian faithful, staring intently at the Crucifixion which should have featured on the facing page. This theory is reinforced by the series of red discs, which are included in each of the

three insets. In all probability, these refer to the eucharist, the symbol of Christ's sacrifice. The circles suggest communion wafers, and their red colouring alludes to Christ's blood. This would fit in well with the general scheme of the page, which combines emblems of the Resurrection (the lions and the peacock wings) with references to the Mass (the vine tendril and the discs).

It is pointless to speculate too much about the form that the Crucifixion would have taken, but the likelihood is that it would have been extremely stylized. Early Christians had shied away from portraying Christ on the Cross, because it was a demeaning form of execution, usually reserved for slaves and common criminals. This only changed in the 7th century, when the third Council of Constantinople sanctioned the theme. Even then, most artists deliberately avoided any sign of suffering, preferring to depict a majestic Christ, dressed in resplendent robes. Celtic miniaturists certainly followed this line. Surviving examples in the eighth-century Durham Gospels and St. Gall Gospels confirm this, while a striking version in the 11th-century Southampton Psalter proves that the trend took a long time to peter out.

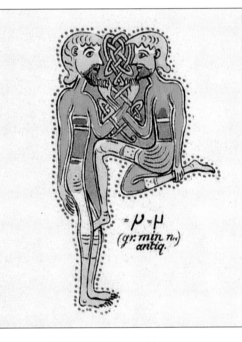

The Drolleries

In addition to the above, the Book of Kells contains a host of smaller, decorative details. In the main, these tiny images appear to stem from the artist's fancy, drawing inspiration from the usual repertoire of biting, tugging, and snaking figures. A few, however, relate directly to passages in the text. On fol. 67r, for instance, the parable of the sower is accompanied by miniature depictions of a cock and scampering hens. Similarly, on fol. 253v, the first letter of the quotation 'No servant can serve two masters' is formed by the figures of two particularly enthusiastic beard-tuggers.

In other places, the allusions are far less clear and there is a danger of over-interpretation. The genealogy on fol. 201r offers a striking example of this. Midway down the page, a hybrid creature, half-man and half-fish, appears to single out an ancestor of Christ's named 'Iona'. He does this by having the figure take hold of the word 'Fuit' on the same line. One theorist has seized on this point, arguing that the artist was trying to draw attention to the origins of the manuscript. By this, he did not mean the island of Iona – for this was known as Hy at the time. Instead, he deemed it to be an oblique reference to St Columba. For the saint's name is the Latin word for 'dove', while 'iona' means exactly the same in Hebrew.

In other parts of the manuscript, the decorative details fulfilled a functional role that was entirely unrelated to the message of the text. This resulted from a scribal practice known as the 'turn

Top detail: Fish-man, fol. 201r.

Above: Beard tuggers, fol. 253v.

exponitur uescendi desiderio collocatio &

quaerentibus fructus laboris & do magiste.

rii doctrina seruetur—

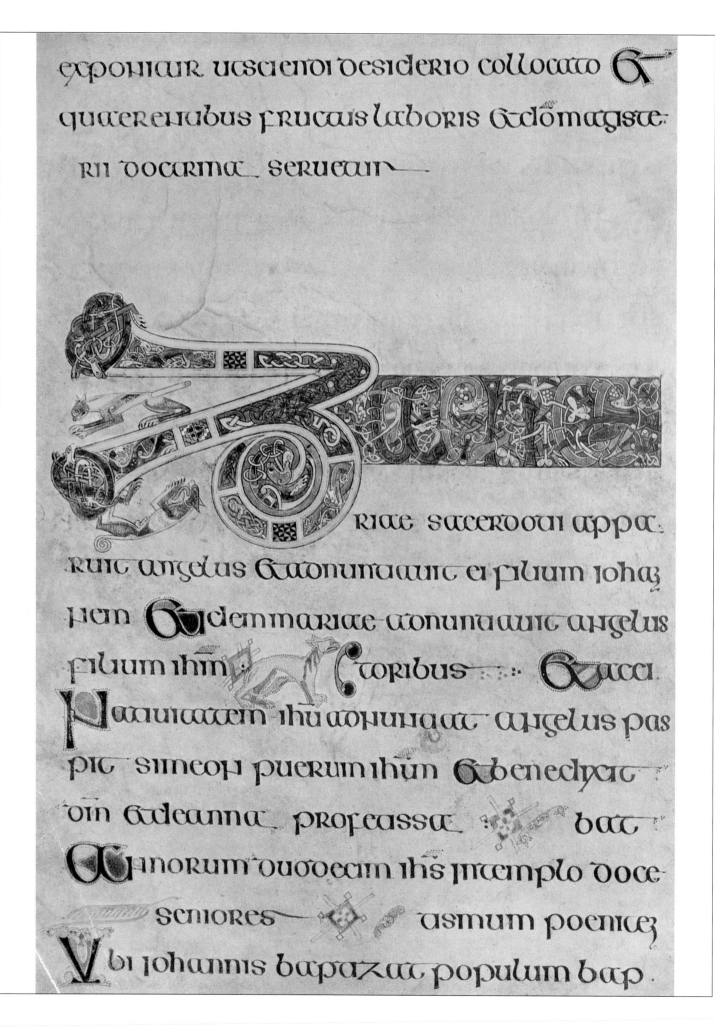

riae sacerdoti appa.

ruit angelus & adnuntiauit ei filium ioha₂

nen & idem mariae adnuntiauit angelus

filium ihm & toribus & uia.

Natiuitatem ihu adnuntiat angelus pas

pit simeon puerum ihm & benedicit

din & leanna prophetissa bat

& anorum duodecim ihs in templo doce

seniores asmum poenitez

Vbi iohannis baptizat populum bap.

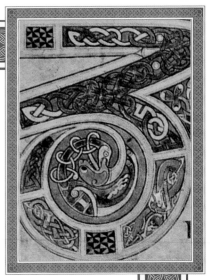

under the path' or the 'head under the wing'. In a bid to save valuable vellum, monks tried hard to avoid leaving gaps at the end of a line. Instead, they would break up the final word, inserting the second part on the line above. This insertion would be signalled to the reader by means of a large, C-shaped bracket. In addition, the end of the previous line was marked with some artistic flourish, to emphasise that the sentence was complete. Three examples of this process can be noted in the text of fol. 19v. Five lines below 'Zachariae', the word 'pastoribus' is split in two. A dog and a green bracket sign mark the spot. Lower down on the page, there are two further examples, where the words 'docebat' and 'baptismum' are separated. In these cases, the division is highlighted by a yellow bracket and a diamond-shaped motif.

Decoration

The remaining decoration in the Book of Kells is made up from a variety of ornamental motifs, which had been at the core of Celtic art since the La Tène era. The simplest component was interlacing. This had developed out of

Opposite: Breves causae, fol. 19v.

three-dimensional crafts, such as basketry and textile-making, though it also had long associations with manuscript illumination. It was featured prominently in the Book of Durrow, but Coptic artists were also very fond of interlacing – a fact which has encouraged historians to speculate on possible links between the two traditions.

Interlacing could be used rather lazily, as a convenient method of filling large areas of vellum with a repetitive pattern. The Kells artists, however, employed the motif most inventively. They varied the width and colour of the strands enormously, to create a beguiling sense of movement. This can be seen to good effect in the miniature of the Virgin and Child, where the border positively seems to writhe with a tangled mass of snake-like forms.

Knotwork was closely allied to interlacing. It could be employed to produce smaller, densely-packed areas of decoration, and it was also useful for filling up awkward spaces, such as corners. In order to do this, designers

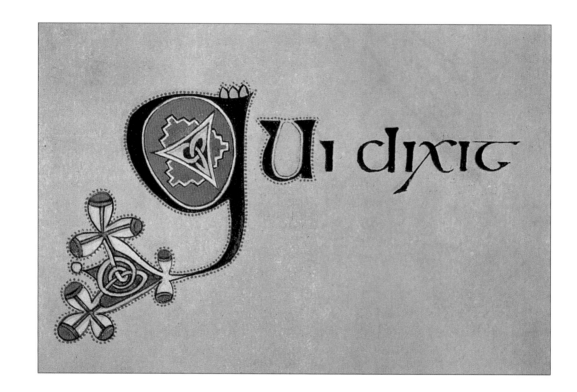

would often give their strands sharp, pointed ends, something that a weaver could not hope to emulate. Knots could also be symbolic. One of the most popular Celtic devices was the triquetra or triangular knot, which was frequently used to represent the Trinity. Examples of this can be found on the Crucifixion Page (fol. 124r). The small yellow triangles in the lower half of the page contain pink triquetras, and the motif can also be seen at the end of the word 'crucifixerant', where it is formed by a ribbon-snake.

Spirals were another staple feature of Celtic design. As with interlacing, this pattern can be found in other, more ancient cultures, but Celtic illuminators brought it to a new peak of refinement. They achieved this by varying the design at the centre of the

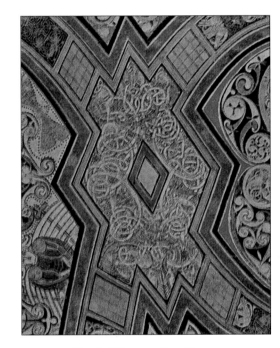

Detail of Monogram Page, fol. 34r.

Opposite: Triquetra in initial Q.

spiral, and by grouping several spirals together in elaborate formations. Instead of simple, one-coil spirals, they normally employed three or four-line versions. The triskele or three-legged spiral was a particularly popular variant. In the Book of Kells, the most spectacular examples are located on the Monogram Page and the Carpet Page. At first glance, the design of the latter appears rigidly symmetrical. Closer examination of the eight large circles, however, reveals an explosion of spirals within spirals. This is even more apparent on the Monogram Page, where spirals nestle in every curve of the huge letter 'X'. In most cases, adjacent pairs rotate in different directions, thus creating a sense of

balance which helps to counteract the giddying swirl of the overall design. The use of spirals was not confined to abstract decoration. Often, it extended to the portrayal of figures and animals. Thus, in the portrait of St. John, the Evangelist's kneecaps are represented by two delicate spirals, one turning clockwise and the other anti-clockwise.

Celtic artists felt no compunction about transforming human or animal features into decorative patterns. Obviously, if it was necessary for the context of the illustration, they could produce recognisable lions, peacocks and eagles. But, when the opportunity arose, they also delighted in distorting or breaking these creatures down into ornamental motifs. It required little effort to turn snakes into interlacing or knotwork patterns, but the Kells illuminators were much more ambitious, including birds, quadrupeds and human figures in their repertoire. In general, they used two stock methods. Sometimes they would take an abstract form – a border or a strand of interlacing, for example – and add a head and a tail at either end. More often, they would draw a figurative shape and then transform one or more of its appendages – a tail, an ear, a tongue, a beard – into a piece of ribbonwork. This would then be woven into the surrounding design, so that the figure was caught in its mesh, like a fly trapped in a web.

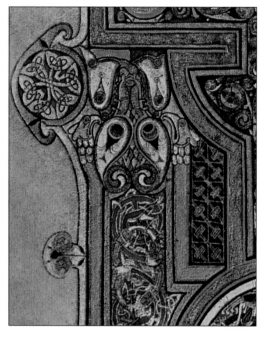

Detail of Initial Page, St Luke's Gospel, fol. 188r.

The most elaborate patterns involved two or more figures. Animals would invariably bite or coil themselves round a neighbour while, for humans, the favourite activity was beard-tugging. Often, there can be a childlike fascination in trying to determine the fate of an individual

limb or organ. At the top of the St. Luke genealogy (fol. 200r), for example, does the man's beard turn into the ear of the creature beneath him? Are those his legs which emerge from the mêlée three or four lines further down? The Celts adored this kind of ambiguity. They also delighted in what is known as the 'cheshire cat' effect – the hint of a face or head, which only becomes clear if the picture is examined closely. An instance of this can be found in the left-hand border of St. Luke's Initial Page (fol. 188r). At first glance, the image may seem a little confused. Soon, however, it becomes clear that we are looking down on a long-snouted beast. Its head is flanked by two small eagles and its snout is clamped between the jaws of two yellow lions' heads.

On a much smaller scale, similar combinations of animals and interlacing can be found scattered throughout the text. By common assent, the calligraphy is one of the outstanding features of the Book of Kells. No other Insular manuscript can compare with it in this respect. The effect is particularly striking in the page-length lists, such as the genealogies and the beatitudes, where the repeated initial letters are treated as a single, vertical design. The same is true of the ligatures of two or more characters, which are often formed out of a pair of warring creatures. In many cases, these letters are virtually indecipherable, emphasising once again that the Book of Kells was designed as a feast for the eye, rather than the mind.

Following page: Southampton Psalter.

3

Enedica dñe toi cpe y tip laur ei ore meo
ñ oño laudabit aia maudiat moręy y letet
Mazmpcate dñm meę y exaltum nó ei io ipę
Exqruj dñm y exaudujit me y ex oibz tbubulatio
nibz meiy eripuit me

2

enedicte oia opa dñi dñm ę mnū
dicite & sñr exultate eū in seła

4

tium euaŋgelij hu xpi
ęlii dī ę rcripto cū y imiftaia ppha
Ecce mitto angelum mm an racie
tuam quj pñeparabit tuā tuiam.
Uox clamunęy in deręto papate
uiam domini rectoy racite rĝmitay huię
ę uit iohannęy in deręto babqẓanę

5

ђ in do mcelbrnte ђrcbñt. ђ. l. mẓxuiii anno
etaęy puæ. Mo aŋabliadatięñ ẓo ktharẓmojnęђ.

7

Clĝ uŋ dicebant ę ne uideum ẓnulin
et heliay libaŋe ę Alẓ hy acchpauŋ lancea
pupuẓit latẓ ei y ex iit aĝ y rangtuę. i hy ђ
ičũ clamanęy uoce maẓna ĝmięt sspm.

8

FINit am ę ——— in it am.

TECHNIQUES

 The production of a manuscript was a slow and arduous process. Each of the materials had to be specially prepared by hand, from the cutting and drying of the animal skins that were used to make vellum (parchment), to the gathering and grinding down of the various substances that went to make up the necessary inks and paints. The most colourful description of these chores can be found in the form of a riddle, preserved in the 10th-century Exeter Book. Here, the riddler outlines the complete process, from the slaughter of the calf for its hide through to the gilding of the binding:

An enemy came and took away my life, deprived me of all my worldly strength; then he dipped me in water and drew me out again, and placed me in the sun, where I soon shed all my hair. After that, a knife's sharp blade cut into me and scraped away all my blemishes. Fingers folded and shaped me, and a bird's feather moved swiftly over my brown surface, sprinkling meaningful marks; it swallowed more wood-dye from a horn's dark rim and travelled over me again, leaving a trail of black marks. Then a good man covered me with protecting boards and stretched skin over me, adorning me with gold; thus I am enriched by the wondrous work of smiths, decked out with gold and crimson dye and bound in a coat of glory.

The first step in the production of any manuscript was the procurement of sufficient animal skins to build up a stock of parchment. Vellum (from the Old French word *velin*, meaning 'calf') could be made from a variety of different hides, although lambs or calves were the most common providers. In the case of the Book of Kells, the monks opted for calfskin. The fragile, thinner pages were made from unborn calves, while a few thicker sheets were taken from animals that were two or three months old. In general, the delicate ivory colouring of the former was preferred but, in those sections of the text where the decoration was particularly elaborate, it made sense to use the sturdiest material possible.

As a general rule of thumb, a single beast could be used to supply one or, at most, two double sheets of vellum. By this reckoning, the Book of Kells would have required the slaughter of almost 200 animals. It is worth stressing this figure, to emphasise that the production of a lavish manuscript involved serious economic decisions and was never undertaken lightly. It also underlines the fact that a small or impoverished monastery would never have embarked on such a project, no matter how fine the artists at their disposal. Cattle were costly, so the creators of the Book of Kells must either have been rich, or else must have received a generous donation from a wealthy patron. This strengthens the argument that the book was produced at Iona for, as head of the Columban group of monasteries, it would have been able to call for assistance from the other communities. It also lends weight to the theory that the Book of Kells was designed to commemorate a specific event or anniversary. Finally, it explains why, even in a manuscript as prestigious as this one, there was a conspicuous attempt to avoid wastage. Every hide was used, even if it had blemishes or tiny holes.

Once the animal had been skinned, the next stage was to smooth out the surface. Often, the hide was dipped in lime, before workmen began the painstaking job of removing the hairs with a knife. The skin was then stretched on a frame and cut to the correct size. Next, the pages were folded and arranged into 'gatherings'. Tiny holes were pricked into the

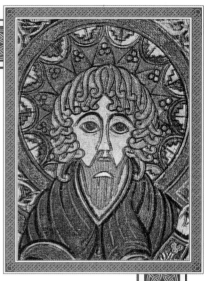

vellum with the point of a knife, to mark the overall writing area, and the individual pages were ruled out, ready for the scribe to begin copying his text.

The best evidence for the different types of writing implement used by illuminators comes from the manuscripts themselves. By the time that work began on the Book of Kells, it had long been the custom to preface each Gospel with a portrait of the author. In these, the Evangelist was frequently shown with a pen or brush, and it is reasonable to suppose that the artist based such pictures on his own working practices. Thus, in the portrait of John, the saint is holding a long quill pen with a tapering point. This was probably made with the tail feathers of a swan or goose. In addition, scribes might also have employed a sharpened reed pen. Examples of this are pictured in other Celtic manuscripts, such as the Lindisfarne Gospels. One of the most unusual versions, the portrait of St John in the Gospels of MacDurnan, shows an Evangelist holding two different types of pen. The same picture also includes a conical inkwell, stuck into the ground in an identical manner to the Kells' St John. For the painted sections of the manuscript, artists would have used brushes made with animal hair. The finest and most desirable were those which came from marten fur.

Detail of St John, fol. 291v.

It is likely that a number of other artistic aids were also in common use. Compasses, set squares and dividers all seem to have been available. There are few hints of their presence in the Book of Kells itself, but visible signs have been found in the Lindisfarne Gospels. By good fortune, the backs of some of

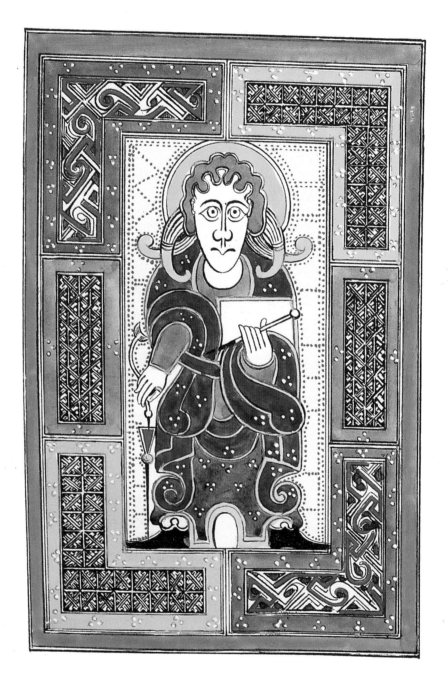

Portrait of St John, MacDurnan Gospels.

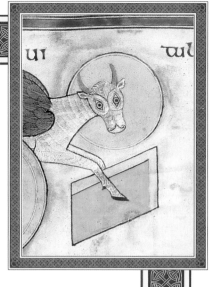

most highly decorated pages were left blank, revealing faint traces of the artist's working methods. The more complex patterns were built up from minutely detailed grids and compasses – which have left tell-tale prick holes – were used to maintain a steady curve. The question of whether artists used templates is more controversial. It is tempting to wonder if some devices of this kind were available, especially as they appear to have been used by stonemasons of the period, but no direct evidence is forthcoming. The same could be said of preliminary sketches, although these must undoubtedly have been executed. Monks would certainly not have been encouraged to use costly vellum for this purpose, but it is quite likely that they made test pieces on perishable wax tablets. These tablets were commonplace in monasteries and there is documentary proof that they were used as compositional aids. In his preface to De Locis Sanctis, Adomnan explained how he persuaded Arculf to make sketch plans of the sites he had visited on wax tablets. These were later worked up into finished diagrams, when the book was written out.

Most of the text in the Book of Kells was written in iron-gall ink, made from the pulp of oak apples and sulphate of iron. The selection of pigments was impressively varied, considerably more so than in earlier manuscripts like the Book of Durrow. Some of the colours were mineral-based, while others were drawn from animal or vegetable extracts. Their geographical origins were equally diverse; substances such as red and white lead, chalk, and woad were all available locally, while lapis lazuli had to be imported specially from Afghanistan. This exotic material, which went to make up ultramarine and a number of other shades of blue, remained an expensive commodity for most of the Middle Ages. In later artistic contracts, patrons would often specify precisely how much of the substance was to be used in the work they were commissioning. Indeed, the very costliness of the material led it to become the standard colouring for the Virgin's robes.

Folium, kermes and indigo also had to be imported, although none of these were particularly expensive. Folium came from the turnsole plant and provided a range of pinks and

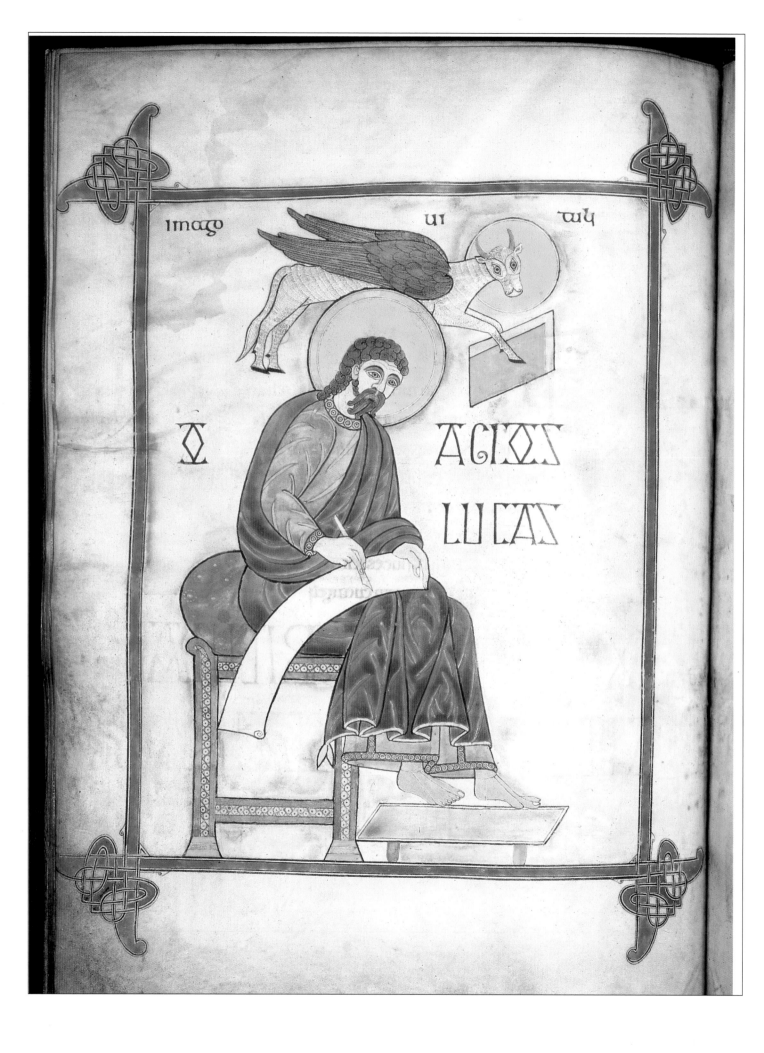

purples. Kermes was a bright red colouring and was obtained from a Mediterranean insect, the *Kermoccocus vermilio*. Surprisingly enough, no gold was featured in the manuscript. Orpiment (yellow arsenic sulphide) was used in its place. This was done out of preference rather than necessity, since gold was readily available. Among other things, it was used in the production of book shrines and coverings.

Most artists of the period utilised egg white as their binding medium, although examples of fish glue can also be found. In addition, the illustrators in the Book of Kells adopted the unusual technique of applying thin washes of colour, one on top of the other, to create a greater sense of volume. This use of glazes can only be found in one other Insular manuscript, the Lichfield Gospels.

The thorniest questions about the creation of the Book of Kells relate to manpower rather than materials. Historians have struggled to resolve two of the most fundamental issues – namely, the number of people involved in the project and the time it took to complete the work. For years, it was

Opposite: Portrait of St Luke, Lindisfarne Gospels.

assumed that the mechanical chore of copying the text must have been a lengthy business. In the late 1980s, however, two modern calligraphers made trial attempts to copy out sections of the Book of Durrow. In doing so, they came up with the surprising assessment that, given reasonable working conditions, the entire text of the manuscript might have been completed in under two months.

This underlines the amount of advance planning that must have been required for a project as ambitious as the Book of Kells. Clearly, the full-page decorations would have taken very much longer to complete and individual sheets must have been earmarked and left blank, while the scribe beavered away at his part of the manuscript. With the larger Initial Pages and the main illustrations, this would probably have presented no problem, but the allocation of space must have been altogether trickier on the smaller Initial Pages and on other ornamented sections, such as the Breves causae and the genealogy.

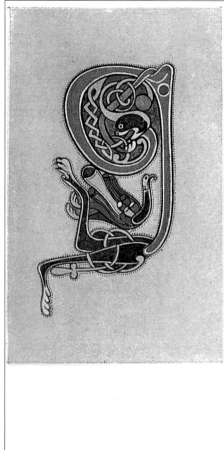

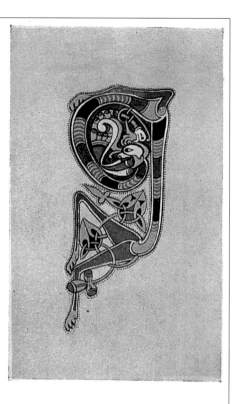

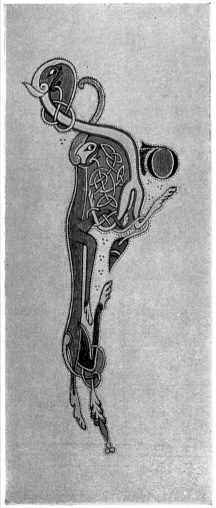
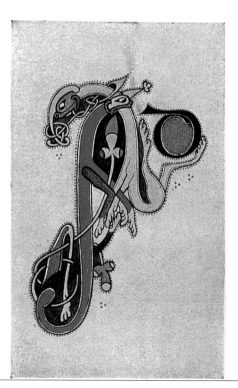
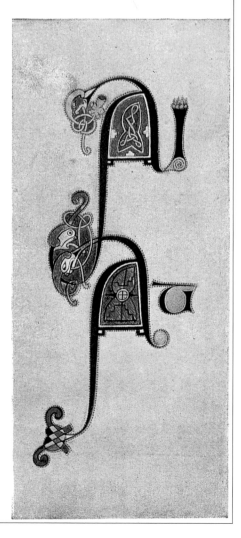

There is also the question of how far the roles of scribe and artist overlapped. It is tempting to imagine that these different fields of expertise were reserved for specialists, but this may be a false assumption. There are no clues in the Book of Kells itself about the division of labour, but certain conclusions can be drawn from other manuscripts of the period. In the MacRegol Gospels, for example, there is a colophon, which informs us that MacRegol both painted ('depincxit') and transcribed ('scriptori') the book. This was confirmed in the Annals of the Four Masters, which added that he was abbot of the Irish monastery of

Birr and that he died in 822. The precise wording of the entry is interesting. It describes MacRegol as 'scribneoir, epscop. and abb. Biorair' ('scribe, bishop and abbot of Birr'). The prominence given to his role as a scribe indicates the high respect that was paid to this kind of work at the time.

The documentation of MacRegol's dual role is unusually explicit, but similar claims have been made in relation to other manuscripts. Ferdomnach, who is known to have worked as a scribe on the Book of Armagh, may also have provided its decorations. The same may also be true of Eadfrith, the scribe of the

Opposite: *Top row: Q R Q*
 Centre: ET
 Bottom: Ad AD AT AI

Below: Section of text from Book of Armagh

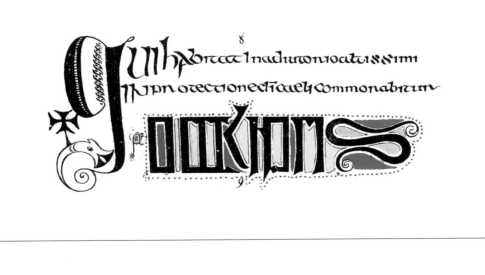

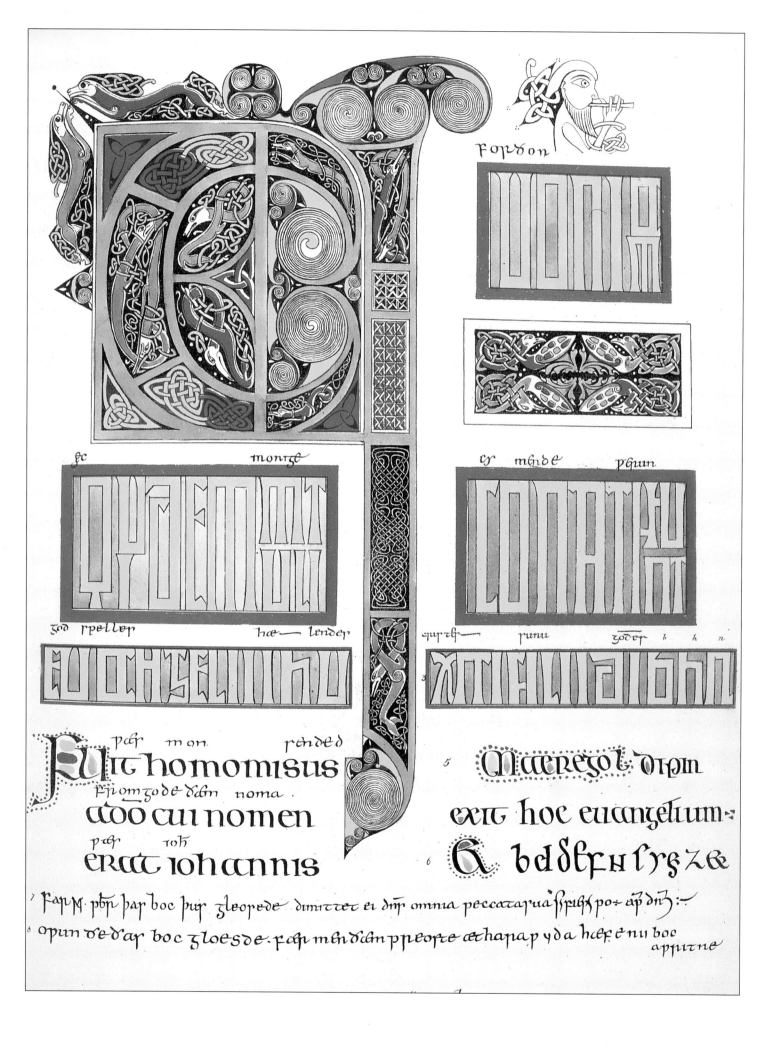

Fordon

ꝼc monᵹe

ᵹod ꞃꝑelleꞃ hæ — lendeꞃ

eꞃ mᵹnde ꝑꞃᵹun

qꝩꞃꝼh — ꞃunu ᵹodeꞃ b h n

paꞃ mon. ꞃenᴅeᴅ

ꝼuit homomisus

ꝼꞃomᵹodeꝺᵹn noma.

aᴅo cui nomen

paꞃ ꞇoh

eꞃaꞇ iohannis

5 **Maeꞃeᵹol ᴅꞇꝑin**

exꞇ hoc euangeliũ

6 **a bᴅᴅꝼꜧ lꞃꝣꝥ**

⁷ ꝼaꞃ M. pꝥꞃ ꝥaꞃ boc ꝥuꞃ ᵹleoꝼeᴅe ᴅimiꞇꞇeꞇ ei ᴅꝛ omnia peccaꞇaꞃuā ꝥꞃꝥꝥ poꞇ aꝑ ᴅꝛꝣ :~

⁶ opun ᴅeᴅaꞃ boc ᵹloeꞅᴅe. ꝼꝗꞃ menᴅꞇꝗn ꝑꞃeoꞅꞇe æꞇhaꞃaꞃ ᵹ ᴅa hæꝼ enu boc

apiꞇne

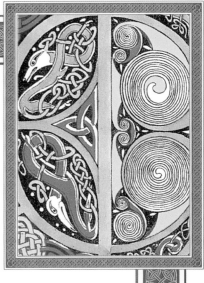

Lindisfarne Gospels. Here, the evidence comes from an inscription, which was added to the manuscript in the 10th century. This named the four chief contributors as: Eadfrith, who wrote the manuscript; Ethelwald, who worked on the binding; Billfrith the Anchorite, the man responsible for adorning the cover; and Aldred, who provided the translation. As no artist is named, it is sometimes argued that Eadfrith may also have fulfilled this role.

It is hard to resist the notion that, in some parts of the manuscript at least, a similar situation existed in the Book of Kells. The very complexity of the calligraphy and its intimate relationship with routine sections of the text make this virtually inevitable. The argument is further strengthened by the fact that several different artists appear to have been engaged on the text. The attribution of individual illustrations to these separate hands has become something of an academic game, largely because it can never be resolved with any certainty.

In her authoritative study of the manuscript, Françoise Henry proposed a system of attribution that is still very widely accepted. She identified three

Opposite: Initial Page, St Luke's Gospel, MacRegol Gospels

distinct personalities behind the artwork, giving these the nicknames of the 'Goldsmith', the 'Illustrator', and the 'Portrait Painter'. She chose the title of 'Goldsmith' for the first artist, because she felt that he reproduced on vellum all the qualities that were to be found in the finest Celtic metalwork and jewelry. In her view, he was the creator of the extravagant decoration on the Monogram and Carpet Pages, the ornate heading on the most elaborate of the Canon Tables (fol. 5r), and the Initial Pages at the start of three of the four Gospels. In other words, he was responsible for all that was most exquisite and delicate in the Book of Kells.

As the name suggests, the 'Illustrator' was more concerned with the narrative and figurative elements in the manuscript. Henry credited him with the composition of the Virgin and Child, the Arrest, and the Temptation of Christ. With some reservations, she also attributed to him the most striking version of the Evangelists' Symbols (fol. 290v) and the Breves causae of Matthew's Gospel (fol. 8r). This artist had a tendency to use more strident

ui	fuit	machad
ui	fuit	iae
ui	fuit	semei
ui	fuit	ioseph osse
ui	fuit	iuda
ui	fuit	iohanna
ui	fuit	ressa
ui	fuit	zorbba
ui	fuit	salachiel
ui	fuit	ieri
ui	fuit	melchi
ui	fuit	addi
ui	fuit	cosam
ui	fuit	elmadam
ui	fuit	er
ui	fuit	iesu

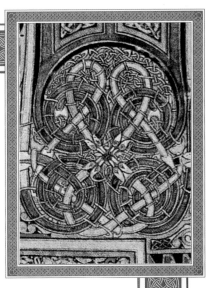

colours, most notably violet and green. His colleague, the 'Portrait Painter', was apparently more conservative in outlook. In addition to the two surviving Evangelist portraits and the picture of Christ, he is thought to have painted the first of the symbols' pages (fol. 27v).

Not everyone accepts this assessment. Some experts believe that the 'Illustrator' and the 'Portrait Painter' were really the same person; others agree that there were two painters rather than three, but they apportion the pictures differently. In addition, there are a few ornamental

pages, which are markedly inferior in quality. The most obvious example of this is the large Initial Page near the start of St Luke's Gospel (fol. 203r), facing the illustration of the Temptation of Christ. Almost certainly, sections like this date from a later period, when an abortive attempt was made to complete the decoration of the manuscript.

Henry also claimed to be able to distinguish the hands of at least three different scribes in the Book of Kells. She classified these simply as 'A', 'B', and 'C' and, as before, sought to

Opposite: The Genealogy of Christ, fol. 200v.

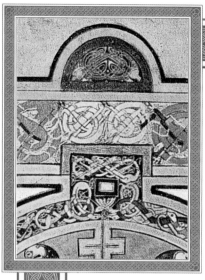

define the mental approach that each of them employed. Scribe A was the conservative, writing in a restrained and slightly archaic manner. He used brown gall-ink and was responsible for the various prefatory texts, the start of St Mark's Gospel, and the closing section of John's book. Scribe B, by contrast, struck her as the 'extrovert' of the trio. He displayed a preference for coloured inks and for ending certain passages with an extravagant flourish. Chronologically, his involvement seems to have come after the others, since much of his work consisted of finishing off individual sections and adding the rubric. The third monk was closer in spirit to scribe A. He used the same brown ink and wrote

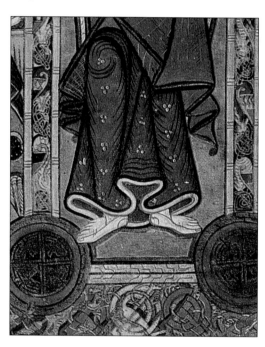

Detail of Portrait of Christ, fol. 32v.

the lion's share of the text, albeit with a slighter freer hand than his colleagues. His rhythmical style is seen at its best in the listings of the Beatitudes and the Genealogy of Christ. Once again, Henry's view has been qualified by some authorities, who claim to detect the handiwork of a fourth scribe.

Further working practices can only be guessed at. There are no preparatory markings or grids, as in the Lindisfarne Gospels, but the incomplete sections in the Book of Kells do offer one or two clues. In particular, they suggest that the miniatures were probably built up, panel by panel, in much the same way as an item of metalwork. The portrait of Christ (fol. 32v) provides a case in point. Near the top of the picture, there are two blank spandrels, which the original artist never managed to

complete. Closer examination reveals that these may not have been the only gaps. If we compare the maze patterns in the two roundels by Christ's feet, it is noticeable that they are much cruder than the gloriously intricate designs in the borders. Undoubtedly, they were added by a later, less talented artist.

From details such as these, it seems clear that little attempt was made to create a single, unified design. Once the central figure had been located in the correct position, the secondary features were tackled independently and compressed into whatever space was left. Evidence of this somewhat clumsy approach can be seen in the portrait of St Matthew. There, the upper part of the Evangelist's throne appears cramped and awkward, as it is squeezed between the curve of the arch and the saint's enormous halo.

Detail of Portrait of St Matthew, fol. 28v.

By contrast, the space available for the arm-rests is far too large, and the artist has been obliged to fill the space by draping superfluous cloths over them.

The work of the scribes called for a very different kind of talent. Copying a text for hour after hour must have been a tedious job, requiring immense powers of concentration. As has been noted, the text of the Book of Kells contains an unusually high number of errors, but this does not necessarily mean that the writing was carried out in a hurried or slapdash manner. Problems could occur just as easily, if there were difficulties with the text that was being copied. In addition to straightforward mistakes, it might

suffer from omissions, illegible handwriting, or indecipherable abbreviations. The Insular taste for decoration also created difficulties, as individual words and letters were frequently rearranged and transformed, becoming virtually unrecognisable in the process.

Once a text had been transcribed, it was normally checked through for errors by a senior monk. This, too, was a laborious task. In Adomnan's Life of Columba, one of the anecdotes concerned a young copyist, who went to one of his fellow monks and asked him to read through a psalter that he had just written. At this point, Columba intervened and asked him why he was imposing such a wearisome chore upon his colleague. Just by looking at the volume, he could tell that the text was perfect, apart from the omission of a single letter. The very fact that this incident was included in the saint's miracles betrays an element of wish fulfilment on Adomnan's part that will be shared by editors everywhere.

The performance of scribes and illuminators was also affected by working conditions within the scriptorium. Later manuscripts showed monks working at desks or lecterns, but this may not have been standard procedure at the time that the Book of Kells was written. Indeed, Evangelist portraits in both the Lindisfarne Gospels and the Barberini Gospels show the figures working with books on their laps, perhaps reflecting contemporary practice.

More crucial still were the many hardships, which were part of daily life in an isolated monastery. The intricacy of the designs in some early manuscripts may seem effortless, but the reality would have been very different. There would have been times when the monks' fingers would have been numb with cold, when their eyes would have ached from the strain of copying a poorly transcribed document in murky light, all of this while their bodies were exhausted from the rigours of rising early for prayer and toiling at their other duties. Add to this the bitter chill of a northern winter and the ever-present threat that, at any moment, all their efforts might be swept away in a single Viking raid, and the achievements of the monastic artists do indeed appear to be little short of miraculous.

Glossary

Argumenta	Prefaces containing details about the Evangelists
Breves causae	'Brief Topics'; narrative summaries of the Gospels
Canon Table	Reference table listing comparative sections of the Gospel text
Carpet Page	Ornamental page in Gospel Book, mainly consisting of abstract patterns
Colophon	Inscription at the end of a manuscript
Columban monastery	Monastery following the teachings of St. Columba
Flabellum	Liturgical fan
Folio (fol.)	Leaf of a manuscript, numbered on both sides. Recto (r.) is the front and verso (v.) the back
Gospel Book	Manuscript containing the four Gospels
Hallstatt	Prehistoric period, named after an Austrian cemetery
Initial Page	Page of ornamental calligraphy, often featured at the start of a Gospel
Insular	Produced in Britain or Ireland, as opposed to Continental Europe
La Tène	Prehistoric period, named after a Swiss archaeological site
Monogram Page	Page of ornamental calligraphy featuring Christ's monogram
Psalter	Manuscript containing the Book of Psalms
Scriptorium (pl. scriptoria)	Monastic workshop where manuscripts were produced
Torc	Metal collar worn by high-ranking Celts
Triquetra	Triangular knot
Triskele	Three-legged spiral motif
Tympanum	Semicircular arch above a doorway
Vellum	Parchment made of animal skin

Bibliography

Alexander, J.J.G. – A Survey of Manuscripts Illuminated in the British Isles, vol. 1 Insular Manuscripts 6-9th c., Harvery Miller, 1978

Anderson, A.O. & M.O. ed. – Adomnan's Life of Columba, Thomas Nelson & Sons, 1961

Backhouse, Janet – The Lindisfarne Gospels, Phaidon Press Ltd, 1981

Brown, Peter – The Book of Kells, Thames & Hudson, 1980

Chadwick, Nora – The Celts, Pelican Books, 1970

De Hamel, Christopher – A History of Illuminated Manuscripts, Phaidon Press Ltd, 1994

Henderson, George – From Durrow to Kells, the Insular Gospel Books 650–800, Thames & Hudson, 1987

Henry, Françoise – The Book of Kells, Thames & Hudson, 1974

Meehan, Bernard – The Book of Kells, Thames & Hudson, 1994

Meyvaert, Paul – The Book of Kells and Iona, Art Bulletin 71, 1989

Nordenfalk, Carl – Celtic & Anglo-Saxon Painting, Chatto & Windus, 1977

O'Mahony, Felicity ed. – The Book of Kells, Proceedings of a Conference at Trinity College, Dublin, Scolar Press, 1994

Spearman, M. & Higgitt, J. ed. – The Age of Migrating Ideas, Alan Sutton Publishing, 1993

Sullivan, Edward – The Book of Kells, Studio Editions, 1986 (1st ed. 1920)

Picture credits

With thanks to the following for permission to use the pictures listed.
Bridgeman Art Library, London: page 82, Visual Arts Library p.48.

Index